IMAGES
of America

STRAWBERRY MANSION
THE JEWISH COMMUNITY OF NORTH PHILADELPHIA

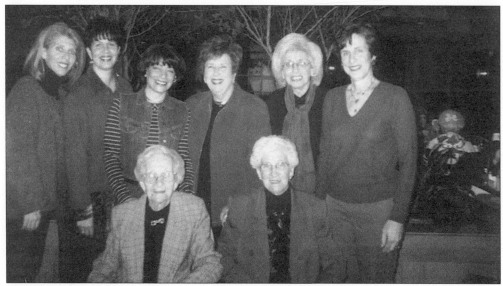

The descendants of Pearl and Abraham Sagalow—Dora Elkins, Ann Lieberman, Edith Golden, Marcia Goldman, Sondra Rech, Amy Gaylon, Judy Pomerantz, and Wendy Parris—celebrate the closeness that the Sagalow's instilled in their children for 50 years after arriving at Delaware and Washington Avenues in 1912 with seven children from Kiev, Russia. The power of family continues with children, grandchildren, and great grandchildren who gather monthly at Philadelphia area restaurants to exchange news of events in their lives and to enjoy each other's company! (Courtesy of Allen Meyers.)

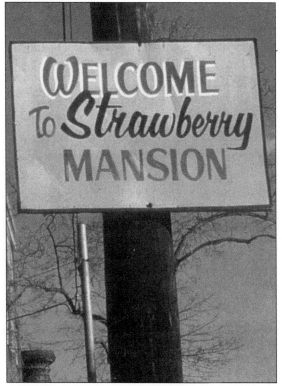

Cover: All aboard the Number 9 trolley car for a trip back in time through Strawberry Mansion. This is a neighborhood and section of North Philadelphia that boasts of thousands of alumni as former residents who have a love for a place they once called home, 40, 50, 60, and even 70 years ago! The feelings go beyond the usual nostalgic attachment. Whenever people get together at social functions and restaurants, the comments include, "do you remember the 'Number 9' trolley car," widely known as the Hebrew Limited or the Jerusalem Express. The Number 9 connected Jewish families in the "Mansion" with relatives living downtown in South Philadelphia throughout the 1920s, 1930s, 1940s, and early 1950s. (Courtesy of Dick Short.)

IMAGES *of America*

STRAWBERRY MANSION
THE JEWISH COMMUNITY OF NORTH PHILADELPHIA

Allen Meyers

ARCADIA

Copyright © 2000 by Allen Meyers.
ISBN 0-7385-0234-0

Published by Arcadia Publishing,
an imprint of Tempus Publishing, Inc.
2 Cumberland Street
Charleston, SC 29401

Printed in Great Britain.

Library of Congress Catalog Card Number applied for.

For all general information contact Arcadia Publishing at:
Telephone 843-853-2070
Fax 843-853-0044
E-Mail arcadia@charleston.net

For customer service and orders:
Toll-Free 1-888-313-BOOK

Visit us on the internet at http://www.arcadiaimages.com

This book is dedicated to my parents.

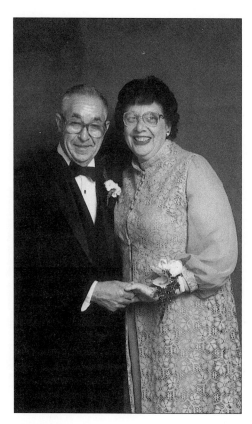

They met at a Chanukah dance at the town hall on North Broad Street in December of 1951 and were married by Rabbi Gershon Brenner on June 1, 1952. During the course of this writing, both of my parents passed away in early 1999. They were sick for many years but never complained—because they had each other!

Leonard Meyers
Son of an American Jewish
farmer from East Greenville, PA.
Beloved father and grandfather
(June 1, 1918–January 13, 1999)

Esther (Ponnock) Meyers
Daughter of
Rose and Louis Ponnock,
Beloved mother and grandmother
(November 20, 1927–March 28, 1999)

—With Great Love and Admiration and both sadly missed by Allen; his wife, Sandy; their daughter, Alisha; Allen's brother, Bryan Mitchell; his former wife, Sandy; and their son, Freddy.

Contents

Acknowledgments . 6
Introduction by Rabbi Fred Kazan . 7
1. Coming to Strawberry Mansion . 9
2. Landmarks . 15
3. A Transportation Hub . 23
4. The Business Districts in Strawberry Mansion 29
5. The Schools and Community Institutions 37
6. Pictures in Fairmount Park . 59
7. The Power of Family . 69
8. The Streets and Houses We Lived In 81
9. World War II Photos . 89
10. Strawberry Mansion Celebrities . 97
11. The Neighborhood Synagogues . 107
12. Moving out of the "Mansion" . 115
13 Strawberry "Mansion Kids" 40, 50, 60 years later 119

ACKNOWLEDGMENTS

How did these photographs become a book? More than 20 years ago, as a graduate of Gratz Hebrew College, I wrote a term paper on my own family's migration around the city, which mushroomed into a lifetime avocation that explored Jewish history of the Greater Philadelphia and South Jersey region. At the outset of the release of my first book with Arcadia, *Images of America: The Jewish Community of South Philadelphia* in October 1998, the conversations began amongst my dearest friends, Donald and Bettyann Gray, who provided a large dose of encouragement. Donald posed the question, "What about a book on Strawberry Mansion?" Donald, a former resident of Strawberry Mansion, offered to have his many friends join the search for family albums of those who now live in Elkins Park, Huntingdon Valley, Lower Merion, and Florida.

In October of 1998, I participated in the *Barry Reisman Jewish Radio Program* to promote my South Philadelphia book in a 10 minute radio spot that turned into a one hour program with scores of people calling the radio station with their own memories. Later that afternoon, Kal Rudman, a well-known personality, took over the microphone and pleaded that a similar book should be compiled on the Strawberry Mansion section of North Philadelphia.

This book was conceived as a tribute to the "Power of Family" and all the implications at the conclusion of the 20th century. Family values best portrayed this community, with many relatives living on the same block or around the corner, and they celebrated life cycle events on a daily basis with large family gatherings during the Jewish calendar year. The closeness and support for happy and sad times shared by a family is very important, even though many Strawberry Mansionites suffered many hardships including the Great Depression and considered themselves poor by today's standards.

I wanted to share the valuable lesson in life that my parents gave to me and my brother, Bryan Mitchell, while residing at 2206 Natrona Street, Thirtieth and York, and 2519 N. Spangler Street in the 1950s—a sense of belonging and pride in the community where we lived.

There are hundreds of people who shared in the quest to portray the area affectionately known as "the Mansion"—a place we once called home! Special thanks to each one of the contributors to this book who took the time to be interviewed at their homes—usually at their kitchen tables over a cup of coffee. Pearl Himmel is one of those special people who deserves credit. For many years, Pearl dedicated time to her book (*A Special Time, A Special Place*), preserving memories of the neighborhood. She gave her full support in locating photos through the many people she reached over the years; her help was invaluable! Pearl deserves a publisher for her work, and I hope to find one!

The greatest help came from my own family. Little did I know that both of my parents would pass away during this time. My parents gave me the strength to carry out this mission, and many people in the community bolstered me when they learned that both my parents had passed away within weeks of each other, early in 1999. Individuals in the community gave me the courage to complete this work through the many tears I shed while typing this book. My wife, Sandy, deserves the most credit because she helped me face reality when she said, in the middle of April 1999, "your parents Leonard and Esther Meyers are together." The "Power of Family" finally hit home!

—Allen Meyers
Sewell, NJ

INTRODUCTION

On a plateau, above the east bank of the Schuylkill River, not far from where trolleys turned around at Thirty-third and Dauphin Streets, a few hundred yards into Fairmount Park, just south of Robin Hood Dell, stand two colonial homes—the Woodford and Strawberry Mansions. In the late 1700s, Woodford was owned by David Franks, a Jewish businessman whose ship transported a bell from England, later called the "Liberty Bell." As for Strawberry Mansion, it was known as Summerville and was ransacked by the British, only to be rebuilt by Judge William Lewis in the early 1800s. Subsequently, the Grime family worked the estate and opened an outdoor restaurant. The fields yielded delicious strawberries, and the cows provided milk and cream. People arrived by steamboat on the river and walked up a brick path to spend a summer afternoon at Strawberry Mansion.

By extension, this area of North Philadelphia, from Oxford Avenue to Lehigh, from Twenty-ninth to Thirty-third Street, along Fairmount Park, became known as Strawberry Mansion. Once a place of summer retreats, the neighborhood became a second residence for German and Eastern European Jewish immigrants who originally settled in North and South Philadelphia in the late 19th and early 20th centuries.

This second book by Allen Meyers is a natural sequel to *The Jewish Community of South Philadelphia*. Though Allen and I are a generation apart in age, we both moved from South Philadelphia to Strawberry Mansion. I moved from Fourth and Manton to Thirty-first and Lehigh, and Allen frequently visited his grandparents, Rose and Louis Ponnock, at Sixth and Morris, while living with his parents, first on 2200 Natrona then moving to 2500 N. Spangler.

My most vivid memory is crossing Lehigh Avenue with my friends to explore a rubble-strewn dirt road between a cemetery and the Central High School athletic fields. Though Central was at Broad and Green, the student athletes practiced at Thirtieth and Lehigh. Amid the debris, we built fires and roasted potatoes, which tasted better than anything I have eaten since!

Once a week, I took the double-decker "A" bus downtown to the Wurlitzer Building on Chestnut Street for my accordion lessons. Allen and I visited our *bubbie* (grandmother) and *zayde* (grandfather) by taking the Number 9 trolley car, the main link between the Jewish populations of South Philly and Strawberry Mansion, that ran from the car barn on Ridge Avenue to Fourth and Ritner Streets.

Saturday afternoons were the best! My sister, cousins, and myself, with carefully wrapped sandwiches in brown bags and money for drinks, went to the Park Movie Theatre at Thirty-first and Diamond Streets, climbed to the highest balcony (just inside the outdoor fire escape), and settled in for a double feature and the serials.

We walked home by way of York Street. For blocks and blocks, the narrow street was lined on both sides with stores of every variety, corner drug stores, delicatessens, bakeries, fruit and produce stores, groceries, over 40 kosher butcher stores, shoemakers, dry goods, and dress stores. York Street ended abruptly at the trolley depot and the entrance to Fairmount Park.

Before the Park was Cherry's ice cream, famous for its glacé-water ices. Later, Pflaumers ice cream parlor opened at Thirty-third and Ridge, and after World War II, even South Philly's famous Pat's Steaks opened an outlet across from the trolleys.

Fairmount Park opened before your eyes. One could stroll by the reservoir, play ball or tennis, fill up a jug of cold spring water, walk to concerts at the Robin Hood Dell, pray at the B'nai Jeshurun Synagogue on Thirty-third at Diamond Streets, and ride the unique pastoral transit

system—the Fairmount Park Trolley (an open air electric railroad coach that is now duplicated as a touring bus). Though you could walk across the Schuylkill River on the Strawberry Mansion Bridge, everyone took the Fairmount Park Trolley to Woodside Park—a wonderland of amusements and rides for all ages.

The neighborhood changed after World War II, as did many urban landscapes in America. Even the view on the cover of this book is no longer visible to one retracing their roots, for both corner buildings at Thirty-third and York Streets have been demolished, the trolley cars stopped running more than 40 years ago, and many of the Jewish inhabitants have passed away, but they left a legacy for all Philadelphians to appreciate in future times.

Today, Jewish Strawberry Mansion only exists in our hearts, thoughts, and memories experienced and shared by thousands of people less than 50 years ago. The Jews built a community, and when they left for such places as the Oxford Circle, Overbrook Park, and West Oak Lane-Mt. Airy, they left behind their houses of worship—the Synagogue buildings at Thirty-second and Montgomery, Thirty-third and Diamond, Thirty-second and Morse, Thirty-second and Cumberland, and at Thirtieth and Cumberland Streets. These buildings have withstood the test of time; they now serve Strawberry Mansion's black community as living monuments and churches.

Allen Meyers's book captures in pictures the family life, the shopping districts, the institutions, the organizations, and the people of a great Jewish neighborhood that flourished in the first half of the 20th century. Tour with him, read and look at the pictures, and enjoy—lest we not forgot where we came from or passed through at some point in our journey through life!

—Rabbi Fred Kazan
Temple Adath Israel on the Main Line

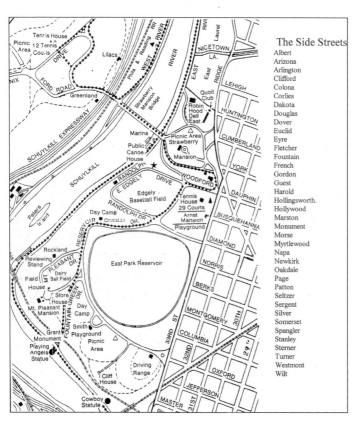

The Side Streets
Albert
Arizona
Arlington
Clifford
Colona
Corlies
Dakota
Douglas
Dover
Euclid
Eyre
Fletcher
Fountain
French
Gordon
Guest
Harold
Hollingsworth.
Hollywood
Marston
Monument
Morse
Myrtlewood
Napa
Newkirk
Oakdale
Page
Patton
Seltzer
Sergent
Silver
Somerset
Spangler
Stanley
Sterner
Turner
Westmont
Wilt

A section in North Philadelphia, high on the banks of the Schuylkill River, was settled as a Jewish neighborhood in the early 20th century. The neighborhood boundaries extended from Thirty-third Street, adjacent to Fairmount Park, eastward beyond Twenty-ninth Street. The section ran north to south from Lehigh Avenue down to Oxford Street. The community divided itself into three segments that consisted of the lower end (below Berks Street), the middle section (from Norris Street to Dauphin Street), and the upper portion of the neighborhood (spread out above York Street to Lehigh Avenue).

One
COMING TO STRAWBERRY MANSION

The Jewish population arrived in the area affectionately known as "the Mansion" in the early 20th century. Upward economic mobility by the German and Irish inhabitants to newer neighborhoods allowed German Jews to settle on Thirty-third Street near Montgomery Avenue. Eastern European Jews flocked to the Mansion to separate themselves from the crowded conditions in South Philadelphia at the end of the new Number 9 trolley car line that ran from South Philly in the early 1910s. Strawberry Mansion became the largest secondary Jewish immigrant district, with 50, 000 Jewish inhabitants, after World War I. The expansion continued in the 1920s as the Mansion developed as a primary settlement district with new immigrants arriving from around the world. After World War II, Holocaust survivors joined newly married, second generation Eastern European Jews in the community. In the late 1950s, as the black community moved into the area, the Jewish community moved out of the area. The remaining Jewish residents moved out of the Mansion immediately after the North Philadelphia race riots near Broad and Columbia Avenues, in 1964.

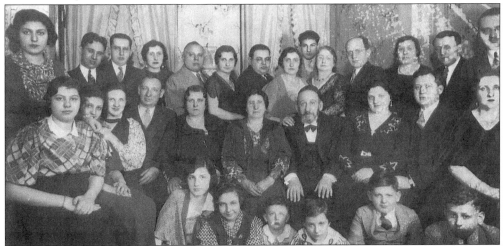

Pearl and Abraham Sagalow came from Russia in 1912 and settled in Strawberry Mansion. The Sagalow family celebrated their 50th wedding anniversary with a family portrait at 3217 Page Street that included the Lieberman, Brod, Peray Rosen, Ledis, Spikol, Elkins, Cohen, and Sagalow families, shortly after they arrived in America. Abraham believed that family was community, and he sold his house in Russia to ensure the safe passage of family members on their way to America. He wanted no one left behind! (Courtesy of Marcia Brod Goldman and family.)

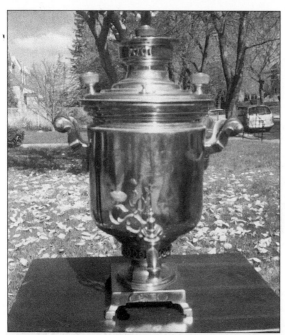

The samovar, a vessel surrounding a charcoal hearth to heat hot water, became a welcome sign for many Russian immigrants to America, according to Old World traditions. Another tradition included lodging a sugar cube between one's front upper and lower teeth while sipping tea. Leah and Israel Auerbach *schlepped* (transported) their samovar to Fairmount Park on Thirty-third Street and dispensed many cups of tea at picnics in the spring and summers from 1920 to 1940. (Courtesy of Bernie Auerbach.)

Leah and Israel Auerbach came from Russia and lived a quiet life in Strawberry Mansion. The emphasis in those days was on family life and the education of children. Israel was elected president of the Aitz Chaim Zichron Jacob Synagogue at Thirty-second and Cumberland Street, but he refused to accept the office because he managed the American Grocery Store at Thirty-first and York Streets on Saturdays. Instead, Israel accepted the treasurer's post. The Auerbach's son, Bernie, became the vice-principal at the Blaine Elementary School at Thirtieth and Norris Streets. (Courtesy of Bernie Auerbach.)

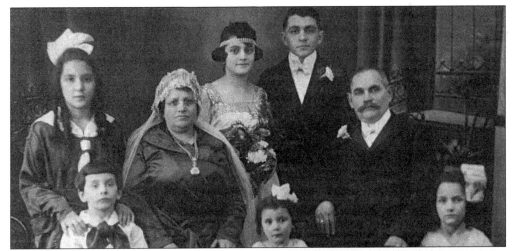

Whole families arrived from Russia and settled in Strawberry Mansion. *Above:* Harry and Rose Skloff left Kiev and settled on the 1900 block of Natrona Street, with their children Henry, Elizabeth, Eva, Esther, David, and Reba in the late 1920s. Harry supported his family by making shoes downtown. (Courtesy of Ed Itzenson.) *Right:* Herman Mattleman's mom, Mary, and her sisters, Liba, Esther, and Leah, helped each other as they found spouses and spread out from South Philadelphia to North Philadelphia. Leah's, husband Tevia Turevetsky taught Mary's husband, Max Mattleman, the trade of a kosher butcher, while Liba's husband Dr. Joseph Levitsky, a community leader and distinguished educator in the Talmud Torahs, instilled a great appreciation of Jewish education in Max Mattleman. (Courtesy of Herman Mattleman.)

Strangers helped strangers as a way of life in Strawberry Mansion. Mrs. Shectman, mother of Elizabeth, Phillip, and Max, was a friend of Pearl Himmel's mother and was considered a *guten nushuma* (a good soul), who loaned money to people in need and gave money to others without asking for collateral or repayment during the Depression. (Courtesy of Pearl Himmel.)

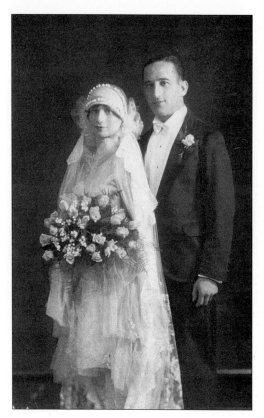

Marriages created and brought new families to the neighborhood. Maurice Silverman, from the Jewtown section of Philadelphia along the Delaware River in Port Richmond, met his future wife, Shirley Spector, at her family Passover Seder at 3128 Montgomery in the mid-1920s. The couple were married on November 16, 1928. (Courtesy of Joan Gross.)

Business opportunities attracted Jewish people to Strawberry Mansion. Morris Baron migrated to the neighborhood from Camden, New Jersey, in the 1920s and opened the Morris Deli at 1951 N. Thirty-first Street. Morris married Anna, and they lived at 2944 Arizona Street. Especially proud of his home, Morris had a gold chain made with his address on it. (Courtesy of Jeannie Berger.)

Jews arrived in the Mansion by way of Woodbine, New Jersey. Nathan Weinstein came to America from the village of Gorodnitza (outside of Zitomer), Russia, in 1898. Nathan lost his first wife during childbirth and, according to Jewish law, married his wife's sister, Rachel. The couple immigrated to the Baron DeHirsh farming community in Woodbine, New Jersey. The family, with eight children, followed the national trend when they migrated from the country to the city in the late 1910s. The Weinstein's resided at 1963 Patton Street. (Courtesy of Jack Weinstein.)

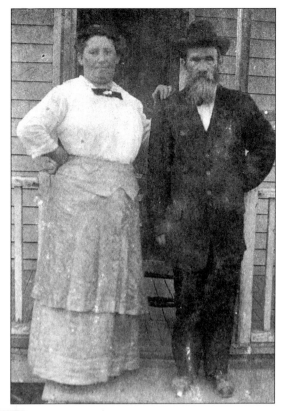

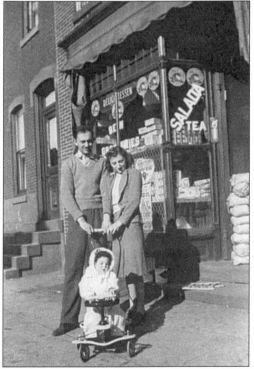

Jewish people have an affinity for living among other Jewish people. The idea of religious and personal freedom in America for Mary and Ben Longer, natives of Kiev, Russia, was a learning experience. The couple was married at Uhr's Restaurant at Fifth and South Streets and later opened a business at 2001 Gratz Street near Nineteenth and Norris Streets. The family moved to a Jewish neighborhood (2637 N. Thirty-first Street), so their children could have Jewish playmates. (Courtesy of Rhea Applebaum.)

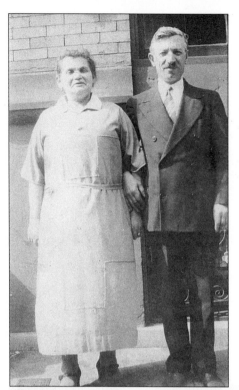

Jews from around the world lived in Strawberry Mansion. Pearl and Morris Podbress came from Riga and Kiev, respectfully. The couple lived in London for ten years before immigrating to 2900 Albert Street in 1929. Morris was a presser of men's pants for Howard's Clothes on South Street. Strawberry Mansion was home to many English Jews after World War I. (Courtesy of Ron Pearlman.)

Odessa Jews were represented by the Perch family. Louis, a carpenter contractor, and his wife, Katie, along with their children, Morris, Reba, Sam, and Minnie, came to America in 1901 and settled near Seventh and Girard Avenues. In 1915, the Perch family migrated to the Mansion and settled at 3214 Monument Street. Louis belonged to the Kerem Israel Synagogue at Thirty-second and Morse Streets. He is best known for his love of the Clair American Legion post and the actual construction of its social hall at Thirty-third and Fontaine Street in the 1920s. (Courtesy of Gil Perch.)

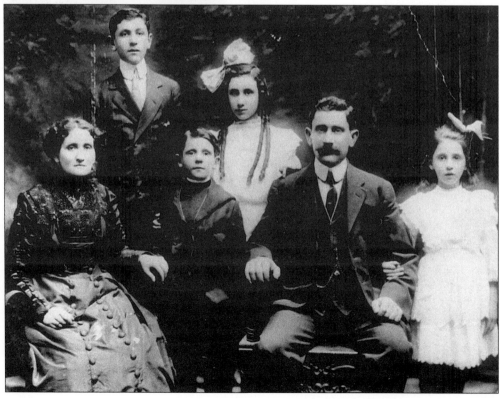

Two
LANDMARKS

Strawberry Mansion is best known and remembered by its vast number of sights, common only to this neighborhood. The neighbors appreciated the many venues in their own backyard, and people from around the city came to enjoy the area, too!

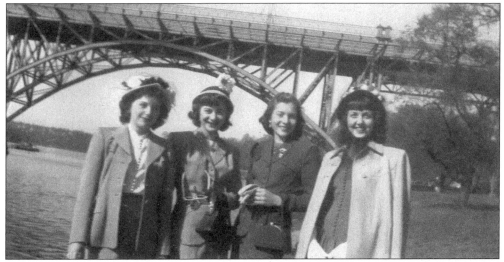

The Strawberry Mansion Bridge symbolized the qualities of the neighborhood—bold and strong, yet glamorous! The Industrial Age in America developed technologies, which allowed cities to build large arched bridges over deep rivers. The Phoenix Bridge Company erected the Strawberry Mansion Bridge in the mid-1890s to connect Strawberry Mansion to the west bank of the Schuylkill River. Marcia Goren, Fran Glassman, and friends posed, as many folks did, under the great arched bridge only a short walk from Thirty-third and Dauphin Streets. The bright-green bridge stood as a testament to a new era with its wrought iron work, walkway, a trolley car track, and a view over the river that rivaled anything in Europe. In 1999, the bridge still stands and was recently rededicated after years of renovations. (Courtesy of Marica Goren and Donald Gray.)

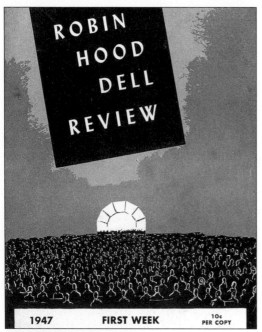

The Robin Hood Dell, only a block away from the Strawberry Mansion Transportation Hub at Thirty-third and Dauphin Streets, opened in 1930 as a world-class open-air amphitheater. This venue was so popular that many people sat on the hillsides, tucked in blankets, and spread out under the stars to listen to the great sounds of the Philadelphia Orchestra and leading bands of the time. The sounds of great music could be heard for blocks beyond the park. Hucksters sold novelties and parked automobiles for a nickel tip in the early 1940s. The Jewish connection was most notable with the likes of Jan Peerce, Fredric Mann, and Henry E. Gerstley at its helm. (Courtesy of Nathan Lipshutz.)

The Strawberry Mansion, located in Fairmount Park only a couple of blocks from the corner of Thirty-third and Dauphin Streets, is one of seven historic houses dating back to the Revolutionary War. The story of how the large house gained its name is legendary and part of Philadelphia folklore. People traveling from points north of the city stopped here to enjoy strawberries and cream in the spring. Nearby Woodford Mansion held a special place in Jewish history; David Franks and his partner, Nathan Levy, founder of Congregation Mikveh Israel, the oldest synagogue in Philadelphia, purchased the home in 1772. (Courtesy of Hannah Silver.)

Cherry's of Strawberry Mansion was an "institution" at the corner of Thirty-third and Dauphin Streets. When the Robin Hood Dell opened in 1930, an eatery was badly needed to feed the large crowds of music lovers. David and Terry Cherry began selling hot dogs for a nickel along with glacé or shaved water ice novelty. The outdoor cafe had seating similar to a Paris, France, cafe. During the World War II, the menu was expanded to include platters and fish cakes. The improvements did not stop! The Cherrys built a sunken dining room, nicknamed the Cherry Pit, which was renowned. The Unterberger family bought the business in the 1950s and ran it for another decade before it closed. (Courtesy of Louis Tootchen.)

Pat's Steaks was legendary throughout Philadelphia dating back to the early 1930s in South Philadelphia. The steak sandwich, a minute steak grilled with fried onions and peppers on the side, was a Philadelphia innovation that rivaled the hoagie, soft pretzels, and Tasty Cakes! In the 1950s, the Olivieri family, headed by Pat (thus the name), opened a second store in Strawberry Mansion on Ridge Avenue below Thirty-third Street, down the street from Pflaumer's Ice Cream Parlor. Betty Levin worked in the store cutting 50 pounds of onions a day! The rumors about the kind of meat used was only that—a rumor! In fact, the Cross Brothers Kosher Butchers supplied the meat according to a reliable anonymous source. (Courtesy of Lenny Davidson, who started a book on Strawberry Mansion, only to realized that he could not complete it due in his own words "I wasn't from the Mansion.")

The American Indian statue in Fairmount Park was a landmark in the Park at Thirty-third and Dauphin Streets. The statue gave people a sense of direction when surrounded by many trees! Turn right, and the road led to a long line of people with various vessels to store the ice-cold spring water that spilled from the age-old rocks. Nathan Lipshutz thought it was important to share the location of the statue with his son, David, one day in the spring of 1973. Nathan and his wife, Gloria, shared that same information with their other sons, Harry and Robert. (Courtesy of Nathan Lipshutz.)

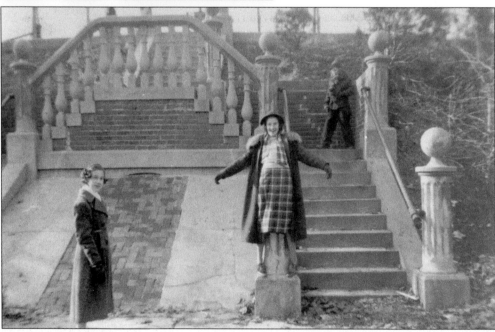

The steps of the "Ressy," leading up to the East Park Reservoir, were a popular spot for many people who lived down in the lower end of the Mansion. The Ressy had a following year-round. Ruthie Rosenberg, whose father owned a drugstore at Thirty-first and Norris, enjoyed the company of her friend, Dorothy Stout from 2027 N. Twenty-ninth and Diamond Streets, at their favorite place to hang out. The Ressy stretched three city blocks and served the residents since its construction in the early 1910s as a source of fresh water. Young and old couples strolled along the road surrounding the reservoir on hot summer nights, and children slid down the slopes of the Ressy in the wintertime. Everyone respected its awesome power and rarely ventured close to its rim. (Courtesy of Shirley Matkoff.)

The fountain in the park was a popular attraction for all ages. The large stone fountain was built in 1926 for the 300th anniversary of the founding of Pennsylvania and was located in the "horseshoe" off Thirty-third and Dauphin Streets. Ethel Schneider Krupnick was in love with the fountain! Conservation measures during World War II meant that the fountain was dry, and as a result, the stone deteriorated and was declared unsafe. The fountain was dismantled in the mid-1950s. (Courtesy of Ethel Krupnick and Pearl Himmel.)

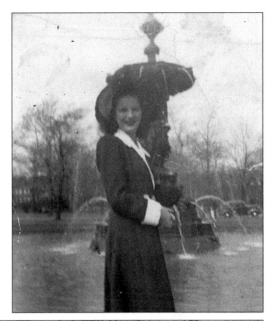

Smith Playground, located in the lower end of Strawberry Mansion, represented organized and supervised recreation, a tradition that dated to the beginning of the 20th century. The largest wooden sliding board in the world, with room for 30 children at a time, kept hundreds of children occupied, hour after hour, throughout the summer months. Many activities, including swings, merry-go-rounds, monkey bars, wading pools, playrooms, and a real playhouse for shows, meant that children could play off the streets in Fairmount Park, safely, all day long. (Courtesy of Allen Meyers.)

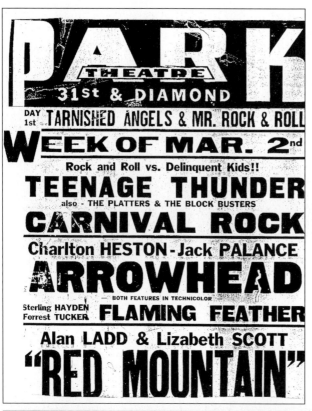

The Park Theatre, located at Thirty-first and Diamond Street, kept many children occupied on Saturday afternoons from noon until 5 p.m. A walk to the Park Theatre was also a treat with a usual stop to candy stores nearby. Children paid 10¢ for admission and were left in the care of Mr. Lewis, the manager, and his daughters, Phyllis, Gail, and Janice, to enjoy an afternoon of fun. Children participated in yo-yo contests and watching their favorite serials, cowboys, news reels, and cartoons. In the 1950s, to lure people from their new found love—television—Tuesday nights were reserved for giving away quality dish ware. (Courtesy of Al and Thelma Schwartz.)

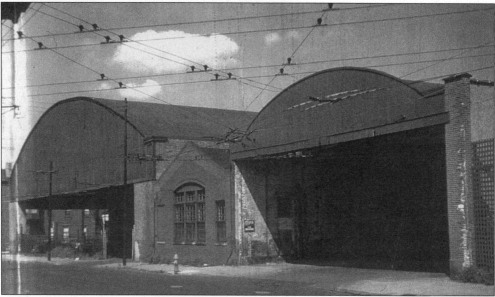

The Car Barn, at Thirty-second and Ridge Avenue, was a fixture in the neighborhood going back to the early 1910s. It was where trolleys were sheltered from the weather and repaired so that they could go back into service the next day. The love of the trolleys for transportation was shared by all in the community. The aging facility was torn down in the 1970s to make way for the Strawberry Mansion Junior High School. (Courtesy of Joe Mannix.)

The Philadelphia Zoo was located on Girard Avenue at Thirty-fourth Street. The shelter for wild animals was the first one of its kind in America, dating back to the American Centennial (1876) held in Fairmount Park. A walk to the zoo from the Mansion was a memorable activity shared by Larry Miner's brother, Bob, and their two children, Howard and Kathy. Another attraction for many years was the Hy Schwartz Yellow Roast Beef truck, which served many tasty sandwiches near the zoo. (Courtesy of Sylvia Green.)

Shibe Park, home of the Philadelphia Athletics and the Phillies Baseball teams, stood out as an institution for boys of all ages since it inception in 1908. The baseball stadium, located at Twenty-first and Lehigh Avenues, was only a 20 minute walk from Strawberry Mansion. Kids from around the city were treated to seats by the Knot Hole Club for free. Morrie Arnovich, a local talent, played for the Phillies in the 1930s. (Courtesy of Carl Hoffman.)

The Park Lane Apartments, on Thirty-third Street between Susquehanna and Diamond Streets adjacent to the B'nai Jeshurun Synagogue, represented luxury living in the Mansion during the 1920s and 1930s. Apartment-dwellers in Strawberry Mansion were considered a different type of people by most neighbors. Although they contributed to the dynamics of the community, in later years many elderly people stayed in those apartments because of that sense of community. Jewish Federation Housing, with its high-rise apartment buildings in Northeast Philadelphia, was spawned with the direct help of Ephraim Goldstein and Joshua Eilberg, because some refused or could not move during the rapid Jewish migration out of the Mansion in the 1960s. (Courtesy of Allen Meyers.)

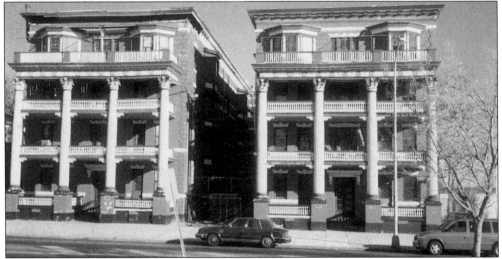

From the 1910s to the 1950s, the Plaza Apartments, at Thirty-third and Clifford Streets, was the home of many families who enjoyed the park setting and the many amenities of the Mansion. The twin buildings were designed by Frank Hahn, the architect who designed the Beth Israel Synagogue at Thirty-second and Montgomery Avenue. The design of the apartment buildings, with their large open porches and Victorian flair from the 1890s, was similar to apartment houses in Atlantic City, New Jersey. (Courtesy of Allen Meyers.)

Three
A Transportation Hub

Trolley cars, trackless trolley buses, and diesel buses connected an otherwise isolated section of Philadelphia with the rest of the city in the first half of the 20th century. This chapter is dedicated to Joseph Mannix, who devoted his entire youth to photographing trolleys around the city. Joe took his future wife, Mary, on dates to ride alongside him as he went about his hobby. Today, more than 50 years later, we thank Joe and Mary for "going along for the ride!"

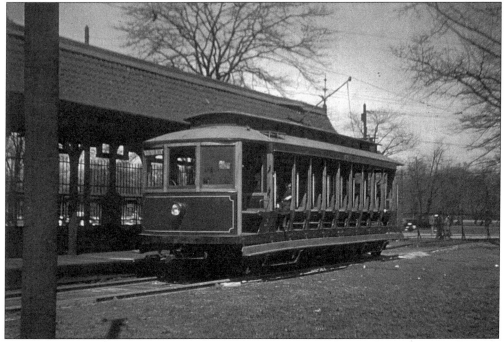

From 1896 to 1946 the Park Trolley, Strawberry Mansion's greatest venue, connected Jewish communities on both sides of the Schuylkill River. The open-air trolley ride in the summer to Woodside Park, Crystal Pool, the lower end of Wynnfield, and Parkside was a treat for thousands of riders, for only a nickel. Adventures through the park and a roller coaster–type ride over the Strawberry Mansion Bridge was a big part of many Strawberry Mansionites lives, especially on hot summer nights. People often took a trolley ride just to cool off! (Courtesy of Joe Mannix.)

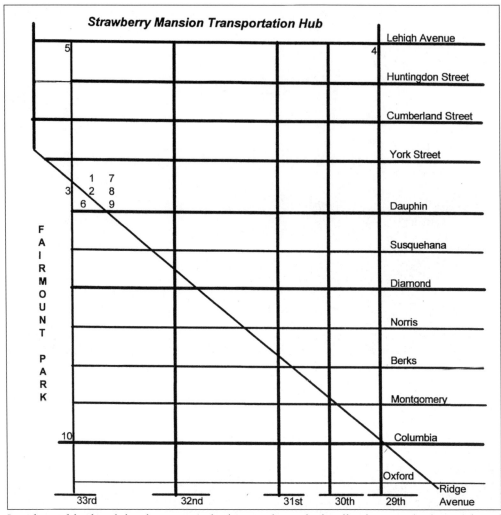

Jewish neighborhood development took place at the end of trolley lines in the late 19th and early 20th centuries. The addition of electricity to those lines made it possible for people to consider a move 3 or 5 miles from the concentrated sections of South and North Philadelphia that had a large bulging immigrant population. A segment of the Jewish population, which included both German and Eastern Europeans, migrated to Strawberry Mansion due to the upward mobility and the convenience of public transportation that connected families, jobs, and access to the downtown area. (Courtesy of Allen Meyers.)

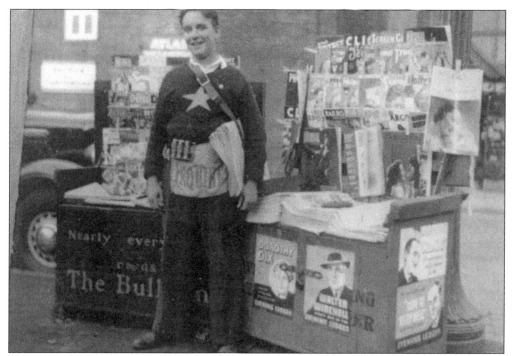

The newspaper stand, outside the Car Barn on Ridge Avenue at Thirty-second Street, was a neighborhood institution. Patton Street's Marty Simon sold newspapers, magazines, and comics to help pay for his first car, at age 16. Marty belonged to the Star Club and met his wife, Ethel Krusen from Newkirk Street, through her parents, Goldie and Sam, who were Marty's customers. Even Dick Crean, from the famous men's clothing store nearby, bought newspapers. Marty's parents, Lilly and Jake, encouraged their son to work hard. Later in life, Marty founded the Atlantic Book Store chain. (Courtesy of Ethel and Marty Simon.)

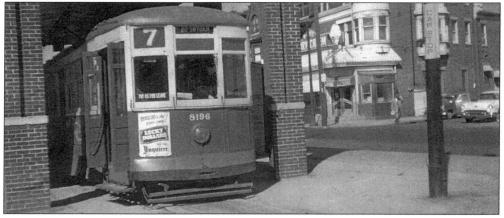

The route #7 trolley ran to South Philadelphia and provided a link that kept Jewish families connected even though they were separated by more than 8 miles within the city. The #7 traveled down Twenty-third Street on the west side of Broad Street, went by the Shaare Shamayim Synagogue at Twenty-third and Wharton Streets in the Point Breeze section, before making a left turn onto Morris Street and heading for Front Street. During World War II, the route was extended straight down Twenty-third Street to the southern hub at Johnson Street to allow transfer to the Philadelphia Naval Shipyard. (Courtesy of Joe Mannix.)

The route #3 trolley line originally ran from Frankford to South Philadelphia along Twelfth Street in the early 1900s. When the Broad Street Subway was completed in the late 1920s, the #3 was diverted over Columbia Avenue to Thirty-third Street in Strawberry Mansion. The Broad Street synagogues, including Keneseth Israel and six other synagogues, were accessible to people living near Fairmount Park. The highlight of the route came at the end of the run in Strawberry Mansion, where it looped around Fairmount Park across from Brownie's Restaurant on Thirty-third Street. (Courtesy of Joe Mannix.)

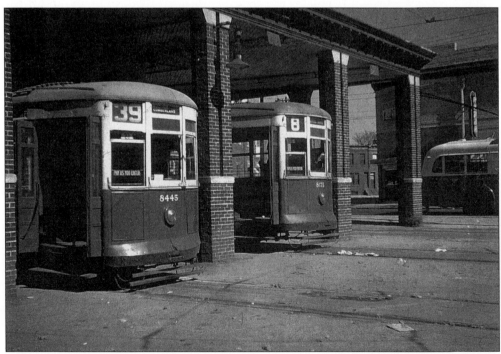

The route #8 and #39 trolleys shared berths next to one another at the depot at Thirty-third and Dauphin Streets. The #8 originally ran to South Philadelphia ending at Fourth and Pine Streets. Migration of Jewish people in the 1910s to points north of Girard Avenue meant that the trolley lines were altered to handle added riders in other parts of North Philadelphia, with a connection to Strawberry Mansion. The Dauphin-Susquehanna corridor was heavily traveled from the Delaware to the Schuylkill Rivers. (Courtesy of Joe Mannix.)

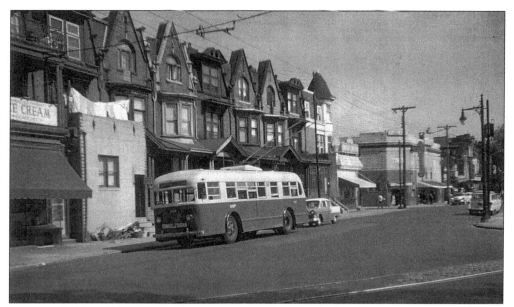

The route #61 trolley connected Strawberry Mansion with the downtown area along Ridge Avenue. Some extended trips to Manayunk became common in the 1910s, where a Jewish community sprouted up on Main Street. To speed riders to the downtown area in the late 1940s, trackless trolley lines and electric buses were created and ran by overhead wires. The route #61 passed by Champs Gym, Pat's Steaks, and Pflaumers Ice Cream Parlor, above Thirty-second and Ridge Avenue. (Courtesy of Joe Mannix.)

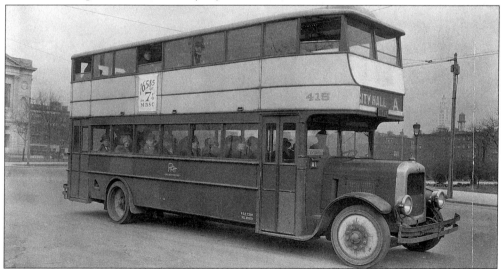

The double-decker route A bus was an oddity in the neighborhood during the early 1930s. The route ran as a test, speeding riders along Thirty-third Street to downtown and to Broad and Pine Streets, where the YMHA (Young Men's Hebrew Association) held dances and basketball tournaments. Children from the Mansion rode the bus to the new Free Philadelphia Library, built along the Benjamin Franklin Parkway, in 1927. The route C, along Broad Street, was the only other line to use the British-style buses, and the cost was a straight 10¢ fair, one way. Many Naval Shipyard workers during World War II used the A bus for their daily journey from the Mansion to work. (Courtesy of Tony Sassa.)

The route #48 trolley ran up and down Twenty-ninth Street through Strawberry Mansion, Brewerytown, Fairmount, and Spring Garden to the downtown area near Front and Arch Streets. The trolley line connected several Jewish communities with door to door service to the Yiddish Theatre at Seventh and Arch Streets. A romance occurred on the #48 in 1926; Doris Atlas and Herman Barnow sat next to one another in the only two open seats, at Broad and Arch. Herman gave Doris the old line that he knew her, and she shot back that it was not true, but "I know you from the Boys' Deli on 31st Street." After only two dates, the Strawberry Mansion couple got married and lived at Twenty-ninth and Norris. (Courtesy of Joe Mannix.)

The route #54 trolley ran along the entire length of Lehigh Avenue from the Schuylkill to the Delaware Rivers. Stops along the way, from Thirty-fourth and Lehigh westbound, included the Drs. Harold and Miram Shore at Twenty-seventh Street; Woolworth's, Sun Ray Drug store, and the Lehigh Movies at Twenty-sixth Street; the Penn Fruit supermarket, Dobbins Vocational High School, and Shibe Park at Twenty-second Street; and Baker's Bowl-another baseball stadium, Philadelphia's North Philadelphia Railroad Station for the Reading RR, and Botany 500 clothing factory at Broad and Lehigh. East of Broad Street lay the Germantown and Lehigh shopping district, Northeast High School at Eighth Street, and Jewtown at Aramingo and Lehigh, where two synagogues dated back to the 1880s. Special islands for boarding the trolley cars were in the middle of Lehigh Avenue. (Courtesy of Joe Mannix.)

Four
THE BUSINESS DISTRICTS IN STRAWBERRY MANSION

"Mom and Pop" stores made up the backbone of the neighborhood. The corner stores and reliable places of businesses bunched up on York, Thirty-first, and Twenty-ninth Streets allowed the Mansionites to shop in their own neighborhood. Entire families operated numerous candy, variety, and ice cream shops. Eating at a corner luncheonette or at the counter of a drugstore was an everyday occurrence that broke the cycle of Kashrut or kosher eating at home. Habits and loyalties to neighborhood eateries became living legends. A large number of Jewish people still maintained a Kosher home and adopted the American motto that a home was indeed a person's castle. A little nosh or Hashrei (tasty non-kosher food.) was okay too—because this is America!

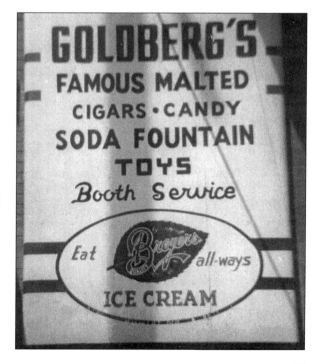

Goldberg's Restaurant, at Thirty-second and Diamond Street, was a wonderful place to just relax and eat good food. In 1935, Max and Anna Goldberg borrowed $300 to open a candy store that expanded with decline of the Depression. Marvin and Arthur Goldberg returned from the war in 1946 to find a wholesale return of their parents' patrons. They enlarged the restaurant, expanded the menu, and installed air conditioning for the benefit of the customers. The hub of the social activity took place late at night when the Park Movies, one block away, let out. The power of family kept this establishment going with aunts, uncles, and grandparent who lived around the corner. (Courtesy of Arthur Goldberg.)

Meyers' Luncheonette, at Thirty-third and Sargent Streets, catered to the neighbors and athletes who passed through the area. The boys in the side streets played half-ball tournaments, and the losers had to buy the snacks. Ed Shapiro and Martin Fader were welcome patrons with their dogs, Rusty and Tippy, who also liked tasty cheeseburgers. The cross country track teams from Dobbins, Central, Gratz, and Northeast High Schools stopped by for that famous, "free cheeseburger" that was always offered "tomorrow." The favorite drink of the day was Puerto Rico Orange Soda, made in Philadelphia. (Courtesy of Ed Shapiro.)

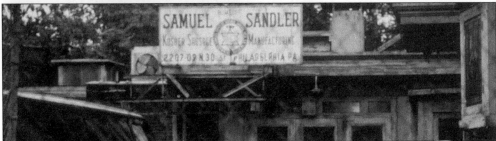

Samuel Sandler's Kosher Sausage and Cold Cuts, located at Thirtieth and Susquehanna Avenue, was world famous for its products. People lined up on Sunday mornings through the rear entrance to purchase their goods that were made on the premises. Israel Sandler came to the Mansion from Russia in 1915; later, Samuel continued the tradition well into the 1980s at the same location! (Courtesy of Allen Meyers.)

The York Street Business District—30th to 33rd Streets	
Anna's Appetizers	Moyerrman's
Berger's Children Wear	Odessa Bakery
Barol's Deli	Norman Kaplan's Dairy Store
Blank's Bakery	Real Estate Office 33rd & York
Blind Barber	Richmond's Bakery
Blind Man Leon's Candies	Rubin's Appliances
Brody's Plumbing	Sam Gordon Texaco
Cleaners & Dye Store	Sailer's Butter & Egg
Dry Goods Store	Schlessinger Kosher Butcher
Evantosh Hosiery	Seligson Deli
Famous Deli	Sol Kasin Grocery
Fresh Chicken/Poultry	Slutsky's Shoes
Finklestein's Paints	Stan's Hardware
Gold's Bakery	Stein's Kosher Butcher
Jewish Restaurant	Tropical Jerry's Fish Store
Joe's Deli	White Rose Butter & Egg
Ladies Wear Store Max Byer's Grocery	Williams Table & Lamps
Mina's Kiddie Store	Wolf's Bakery
Moishe's Fresh Fruit	Zeph's Drugstore
Moskowitz Kosher Butcher	

Left: Families owned and rented homes and lived in apartments throughout the Mansion. Housing was scarce during the Depression and World War II. In the late 1940s, real estate agents aided people in finding housing. Agencies included Meyer Gerber, Isaac Goldstein, Sam Perelman, Arthur Gittleman, Sam Rubin, Arthur Berns, Charlie Wolfson, and Aaron Katz. The Perch Real Estate Agency included Gil Perch (pictured at left); his wife, Shirley Blumenthal; and his mom, Fannie. (Courtesy of Gil Perch.) *Right:* David and Dorothy Salus ran the Salus bakery, which was started by David's father, Abraham, and known for its rye bread. In 1947, the Salus family came back to the Mansion and bought the Ankins bakery at 2018 North Thirty-first Street. (Courtesy of Kay Salus Skloff.)

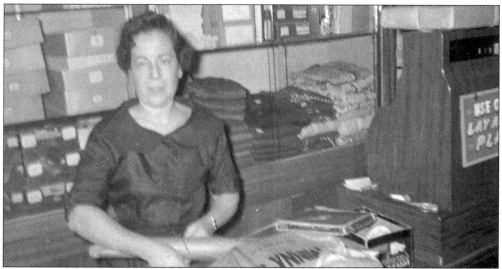

Mina Schwartz ran Mina's Kiddie Shop at 3120 York Street with her husband, Isaac. The couple married in 1941 and decided to move from Logan to the Mansion to run a business. The jobbers all came to her store with their merchandise in the 1940s and 1950s, which was very usual! (Courtesy of Mina Schwartz and Ruth Gurman.)

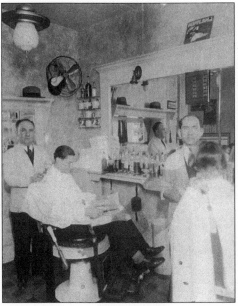

Kobler's Barbershop was located at 2041 N. Thirty-second Street. Max and Lillian came from Russia by way of England in the early 1920s. Some of the esteemed customers were Judge Eugene Lewis, Sam Dash (lawyer and legal advisor to Kenneth Starr), Herman Silverman (founder Sylvan's Pools), Mort Chaverson, Judge Earl Chudoff, Earl Perloff (wholesale food distributor and current president of the AMEC-Jewish Hospital), and Abby Goldman (founder of Lunch Trucks). Lillian had her own beauty shop and cut hair too. (Courtesy of Ed Kobler.)

Sam Chait's Fruit Store, at 1916 N. Thirty-first Street, served as a meeting place. The neighbors knew where to find Sam's son, Donald, to make a minyan for the B'nai Yakov Synagogue, so prayers for the community could be said every night at sundown. Gertrude Chait ensured family unity by insisting that her daughter, Marlene (above), would make deliveries just as Donald did everyday after school. Donald still found time to work as an usher at the Park Movies and later attended LaSalle University. (Courtesy of Don Chait.)

31ST STREET MEN'S BUSINESS ASSOCIATION		
Ankins Bakery	Goodman's Bakery	Rosenberg Butter/Egg
Al's Hardware	Gorsky's Grocery	Rubin's Grocery
Beanery Restaurant	Helfond's Live Chickens	Sailor's Butter & Egg
Ben Hur's Ice Cream	Hoffman's Grocery	Salus Bakery
Berman Hardware	Harriton Dresses	Sam Fish Market
Berkowitz Furniture	Indictors Shoes	Samowitz Shoes
Berstein's Dress	Kaplan's Dry Goods	Segan Shoes
Black's Handbags	Keystone Electric	Seligson Deli
Black the Furrier	Knotty Pine Inn	Schneider's Furniture
Bunny's Luncheonette	Kuerschner Dresses	Shanis Grocery
Burtoff Grocery	Kusher's Dress	Shore's Yard Goods
Cooper's Candy Store	Libby's Appliances	Si-Lo Appliances
Dorfman's Grocery	Marilyn's Dress Shop	Slutsky Shoes
Finklestein Hardware	Mednick Studios	Slutsky Studios
Fishman's Women Wear	Mercury TV	Skolnick's Corsets
Gansky's Restaurant	Michaelberg's Bakery	Smuckler's Furniture
Geller's Candy Store	New York Fish	Starr Deli
Geller's Live Chickens	Ostreich Cleaners	The Nut Store
Germantown B/Egg	Parkway Cleaners	Tissian Pillows
Gerson's Live Chickens	Parkway Deli	Tootchins Fruit Store
Gritz Deli	Poland Jewelry	Wolf's Bakery
Golub Grocery	Potamakin Fish	Weiss Bakery
Goldman's Fruits	Rabinowitz Gen. Store	Weiss Butter/Egg

Members of the 31st Men's Business Association attracted more than 100 businesses in the community. In addition, the kosher butchers, pharmacists, and doctors increased that total to more than 200 and are listed on the various pages of this book.

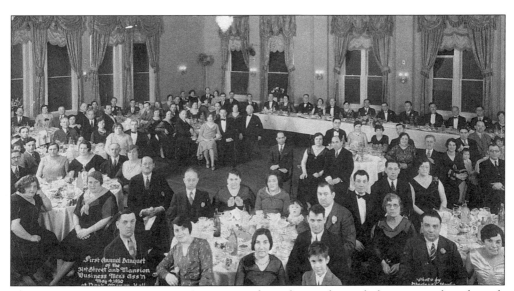

The 31st Street Business Men's Association formed in order to help one another through difficult times immediately after the crash of the stock market in 1929. The first annual banquet was held in 1930, at the Park Manor Hall, and included Thirty-first Street and all the surrounding merchants. The association aided businessmen who needed loans since there were no banks located in the Mansion. (Courtesy of Dr. Leon Berns.)

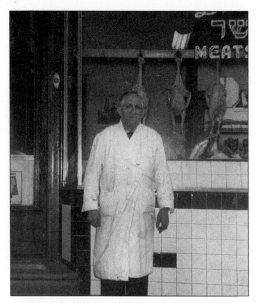

Dave Schwartz, the kosher butcher from 2031 N. Thirty-first Street, worked at this occupation as North Philly changed in the late 1950s. Dave's son, Albert, moved his family to 8522 Temple Road in the late 1950s. Al continued to run errands for his father's friends, delivering kosher meat and poultry around the region, until his father retired in the mid-1960s. (Courtesy of Thelma and Al Schwartz.)

Kosher Butchers 1920–1965

Abe & Lou's………3031 Page	Mars, J……………2007 N. 31st
Abrams, Joe………1748 N. 31st	Mattleman…………2564 N. 31st
Aarons……………2322 N. 29th	Mattleman…………3018 Cumberland
Black, Joe………..1804 N. 31st	Miller……………..1946 N. 32nd
Bornstein,…………1912 N. 31st	Newman……………2564 N. 31st
Cohen, Dave……..1956 N. Stanley	Novack…………….2462 N. Natrona
Ditlow, Sam………2570 N. Napa	Plevinsky, D………1817 N. 31st
Dordick…………..3103 Berks	Raucher……………2914 W. York
Dordick,…………..1924 N. 31st	Schlessinger, A…….33rd & Cumberland
Feinstein………….2471 New Kirk	Schlessinger, J……..3124 W. York
Fine, P……………1933 N. 31st	Schwartz, D………..2031 N. 31st
Ganburg………….2568 Corlies	Segal, S……………2021 N. 31st
Gelutin……………1820 N. 31st	Silver, F……………2462 N. 32nd
Grossman…………1941 N. 31st	Solomon, D………..3028 Ridge
Kaplan…………….2570 N. 31st	Stein, Max…………2121 N. 32nd
Kassman…………..2468 N. Natrona	Stein, Reuben………3115 W. York
Kessler, I………….1946 N. 31st	Strongus……………1741 N. 31st
Kreigler, M……….3020 W. York	Strongus, S…………1727 N. 31st
Maisus……………3028 Ridge	Zubin………………1924 N. 31st
Marinoff, B………..33rd &Cumberland	Waldman, Oscar……32nd & Montgomery
Marinoff, Max…….2500 N. Hollywood	Wallace, C…………2501 Marston
Weinberg, I…………2771 New Kirk	

Oscar Waldman, an officer of the Kosher Butcher Association in Philadelphia, provided many annual banquet books that contained the names of more than 450 kosher butcher shops around the city. Strawberry Mansion had a large number (45) of stores. Chief Rabbi B.L. Levinthal assigned Rabbi Ephraim Yolles to conduct the spiritual guidance of the community and oversee the *kashrut*, or food production, from an orthodox perspective. The appointment lasted a generation, until the end of World War II, which ushered in a radical change of the Jewish population citywide. Rabbi Yolles remarked that the migration and convenience of shopping in new neighborhoods, with the emergence of large supermarkets (ie. Food Fair and Penn Fruit Co.) with many departments, helped to bring the demise of the kosher butchers citywide.

Left: Hyman and Lena Tootchen came from Russia in 1905 and ran a family store located at 1845 N. Thirty-first and later at 1920 N. Thirty-first Street. The business expanded to include groceries and existed until 1978, with the help of Louis and Morris Tootchen. (Courtesy of Louis Tootchen.) *Right:* Charles and Etta Ellis ran a typical general store known as a variety store or a mom and pop shop. The location, at the corner of 2653 N. Twenty-eighth and Oakdale Street, was near the Walton Elementary School and in the Twenty-ninth Street shopping area. Buntzie (Ellen) Ellis often helped serve the customers when not posing for pictures! (Courtesy of Buntzie Ellis Churchill.)

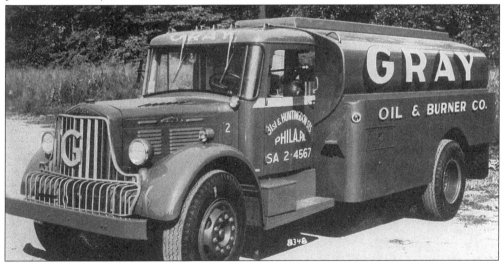

Jack and Anna Gray, from Bessarbia and Romania respectively, arrived in America and settled in Rochester, New York, in the early 1910s. Jack migrated to Philadelphia during the Depression to look for work. The whole family including Beatrice, Seymour, Donald, and Lillian moved to 2609 N. Thirty-first Street in Philadelphia. The "bootleg" coal business was an honest day's work, with men taking large dump trucks to the coal mining regions of Pennsylvania and dispensing fuel to inhabitants of the Mansion. Today, a third generation operates the business. (Courtesy of Bettyann and Donald Gray.)

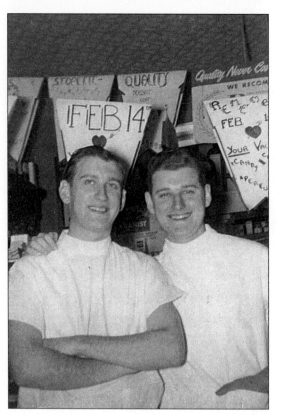

The Zafran brothers, Joe and Stan, posed in their drug store at Thirtieth and York shortly after they graduated from Temple's Pharmacy School in the early 1950s. The boys worked day and night to "mix ingredients and make compounds." Making capsules took longer than other duties because five to ten ingredients were used. This hands-on operation included mixing ingredients to create lotions, ointments, and cough syrups at a time when prescriptions were only 75¢. (Courtesy of Stan Zafran and Donald Gray.)

The Pharmacies in Strawberry Mansion	
Apple's 31st & Berks	Lubeck 31st & Norris
Arnie's 32nd & Berks	Lubin's 32nd & Diamond
Auerback's 26th & Lehigh	Lummis 32nd & Diamond
Bank's 32nd & Euclid	Ostreim's 31st & Huntingdon
Ellis 32nd & Columbia	People's 28th & Ridge
Freedman's 31st & York	Ravitz 32nd & Norris
Gelstz 31st & Montgomery	Ravinsky's 31st & Berks
Greenblatt's 33rd & Cumberland	Robinson's 29th & Lehigh
Jaffe's 32nd & Norris	Rosenberg's 31st & Page
Kay's Ridge & Dauphin	Schwartz 1901 N. 31st
Lerner's 30th & Norris	Zevins 29th & Huntingdon
Levy's 31st & Cumberland	Zitomer's 30th & Diamond

Pharmacists played a major role in the development of the community. After school, men and women settled in the Mansion, where they were raised to serve neighbors and aid in the health and welfare of the community.

Five
THE SCHOOLS AND COMMUNITY INSTITUTIONS

Education allowed the people of Strawberry Mansion to meet each other from the various sections of the community. This social process created friendships for life. People, buildings, and community-based organizations anchored the inhabitants to their surroundings, which in turn created the foundation for Jewish communal life to flourish for more than 60 years.

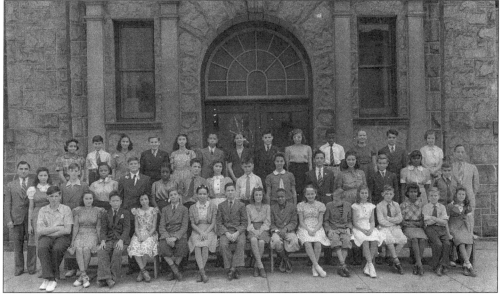

The Walton School, at Twenty-eighth and Huntingdon, served the eastern fringe of Strawberry Mansion. The massive stone building was erected in 1900. Children from Twenty-ninth Street and above Lehigh Avenue attended this school. This 1941 photo included the following: Selma Rothman, Harry Shapiro, Marilyn Dushoff, Marvin Cherin, Mildred Berstein, Lewis Berger, Beatrice Rudinsky, Mr. Ginsberg, Rochelle Fein, Allen Cooper, Bernice Sokolove, Shirley Rosen, Hyman Klein, Ben Wexler, Howard Levin, Midred Goldberg, and many others. (Courtesy Selma Rothman Dubin and Donald Gray.)

The Stokely Safeties made sure children crossed the streets at the corner. The school, built in 1905 at Thirty-second and Berks Streets, served the children until 6th grade. Police Officer Lou Chodak and Principal Kline worked with the safeties. They included Joe Cohen, Arnie Aronovitz, Stanley Shore, Mike Mallin, Mark Blatstein, Gordon Weiner, Skippy Kessler, Joe Becker, and Jay Zimmerman. The safety squad had prestige and status in the community, especially when they worked with Lynn Silverman, the school crossing guard in the mid-1950s. (Courtesy Carl Hoffman.)

נאָטיס צו באזוכער

פאר ערלויבעניש צו באזוכען די
קלאס־צימערעז, ביטע, ווענדעט
זיך אין אָפיס

„וויזיטארס זאלען ניט ערלויבט ווערען צו באזוכען די קלאס־צימערען
אהן דער ערלויבעניש פון דעם פרינסיפאל".

די באארד אן פאבליק עדיוקיישאן
(ווול 8—XII)

The Stokely School served the community for more than half a century with quality education and the ability to impact the community. The sign in Yiddish-Jewish, published by the Philadelphia Board of Education, said "Notice to onlooker—Visitors, if you want to see someone or visit a classroom, you must get permission from the front office." In the 1930s and 1940s, the school held English classes at night for residents who were mostly Eastern-European immigrants. (Courtesy of Ed Itzenson.)

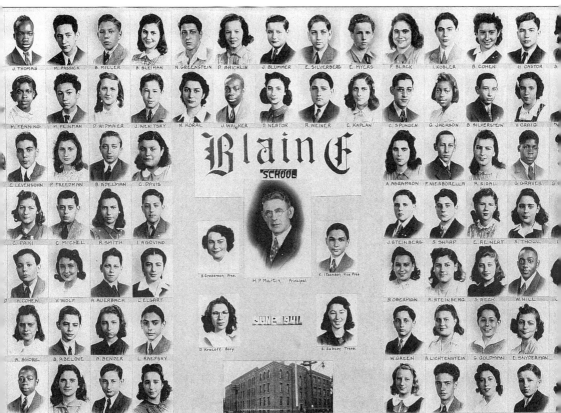

The Blaine School, at Thirtieth and Norris Streets, helped children prepare for junior high school years by assigning them to different rooms for various subjects. The famous Slutsky Studios provided class pictures in this format in the early 1940s. Some of Ed Itzenson's classmates of the graduating Class of 1941, included Debra Bricklin, Jerry Blumer (last owner of Ben Hur's ice cream store), Edward Silverberg (procured meat for Mc Donald's worldwide), Bernie Silverstein (tv star), Bruce Rozet, and Al Singer (who went to Hollywood to act), joined many others in the neighborhood activities including boy Scout Troop #293, joining the Alpha Phi boys club and then went to Central High School (class #184.) (Courtesy of Ed Itzenson.)

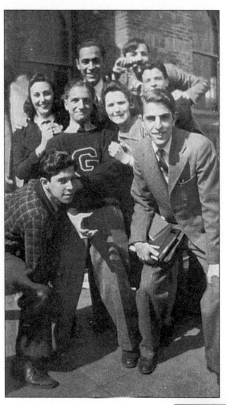

On the steps of Gratz High School, in 1938, high school kids gathered around Ralph Trichon (later, a successful real estate developer). People pictured include Fay Goldberg, Bernie Himmel, Price Berkowitz, Jack Rubin, Manny Shamberg, Sylvia Morris, and Marty Ostroff. (Courtesy of Pearl Himmel.)

Northeast High School, originally at Eighth and Lehigh, represented a traditional approach to high school by accepting only boys. The boys went to school by way of four unique routes. They rode the #54 trolley, "stole a hop" or hitchhiked down Lehigh Avenue, walked for 45 minutes, or received a "transfer" from other students on the #23 trolley that went up Germantown Avenue. In the mid-1950s, Northeast High moved to a new location, retained its name, and turned co-educational. Shown wearing his school letters is Eddie Weinraub. (Courtesy of Ike Silverberg.)

40

Dobbins Vocational High School, at Twenty-second and Lehigh, gave Jewish students the opportunity to learn a trade, including the author. Built in 1938, Dobbins became the third vocational high school in the city and the only one within walking distance of the Mansion. The eight-story high school provided a plethora of classes, including baking, auto mechanics, electronics, and carpentry. Jewish students in the 1950s included the following: Meyer Shhulik, Kurt Sotman, Bernie Fishbein, Toby Barenfuss, Larry Greenberg, Charles Heller, Stan Kravitz, Sheldon Kretchman, Louis Rubin, Harvey Segal, Barry Stein, Don Rubenstein, Fred Falkenstein, Gloria Bomenblit, Gilbert Cohen, and Herb Zarr. (Courtesy of Meyer Shulik.)

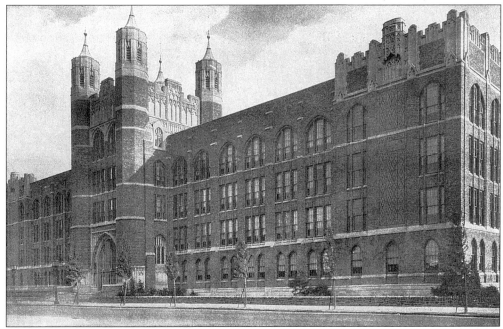

Starting in 1927, Simon Gratz High School served the children of Strawberry Mansion at Hunting Park and Pulaski Avenues. An extensive building program by the school board added five high schools around the city to better serve the growing community of young people. The school was named for a prominent Jew from revolutionary days and attracted many Jewish students from the Mansion who wanted a co-educational high school experience. (Courtesy of Thelma Schwartz.)

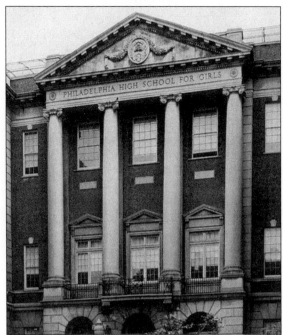

Philadelphia High School for Girls prepared attendees from the Mansion, and from around the city, for successful appointments in life. The school was located at Seventeenth and Spring Garden Streets from 1933 until it moved to Broad and Olney Avenues, in 1958. The Girls high motto was "*Vincit Qui Se Vincit*" (she conquers, who conquers herself). In the 1950s, many Jewish families migrated to new neighborhoods, and three urban high schools moved more than 5 miles to new locations. (Courtesy of Buntzie Ellis Churchill.)

Central High School for Boys served as an educational institution since the formation of the free public school system in Philadelphia, dating back to 1848. Close proximity to the Mansion and to Broad and Spring Garden Streets meant that a large contingent attended Central High School. The school's move to Broad and Olney Streets in 1939 reflected the migration of the Jewish population. (Courtesy of Ed Itzenson.)

Prom pictures hold special meaning years later. The unofficial process for selecting a date for the prom while a senior at Central High School was asking a Girls' High student. It worked out for Marc Pomerantz from Central High School (Class # 203) and Buntzie Ellis Churchill, in 1958. (Courtesy of Buntzie Ellis Churchill.)

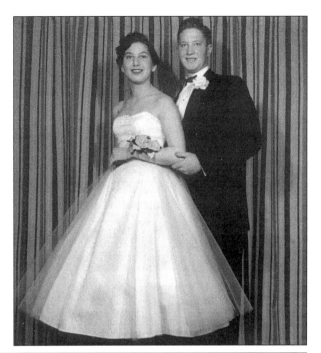

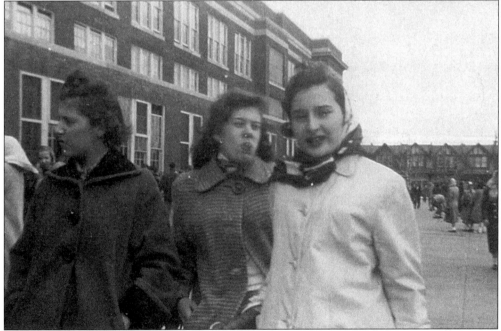

Cooke Junior High School laid outside the boundaries accessible for children of Strawberry Mansion before neighborhoods changed, and the 1953 U.S. Supreme Court ruled on school desegregation. These factors allowed many students to choose their junior high school, which included Gillespie (Seventeenth and Luzerne), Fitz Simmon (Twenty-sixth and York), and Cooke (Old York Road below Wyoming Avenue in Logan). Marilyn Sherman, Edith (Tolizer) Kligman, and Shirley Newman enjoyed each other's company at Cooke Junior High School in the mid-1950s. (Courtesy of Edith Kligman.)

Olney High School, located off Roosevelt Boulevard, became the school of choice for many students. Neighborhood change again drove some parents and children to extremes in order to escape a changing society they had no control over. Parents used the address of their brothers, sisters, aunts, or uncles so that their children could attend a better school, while some resorted to the aid of a local politician to get a transfer for their child. Arlene Smith submitted her cousin's address, 662 Mayfair Street, so she could attend Olney High in 1954. (Courtesy of Arlene Smith.)

Fitz Simon Junior High was located at Twenty-sixth and Cumberland. At one time, five elementary schools in Strawberry Mansion, including Blaine, Saratan, Stokely, Mc Intyre, and Walton, fed Fitz Simon's. Some children throughout the 1920s and 1930s quit school around junior high to get jobs and help their families. (Courtesy of Manfried Mauskopt.)

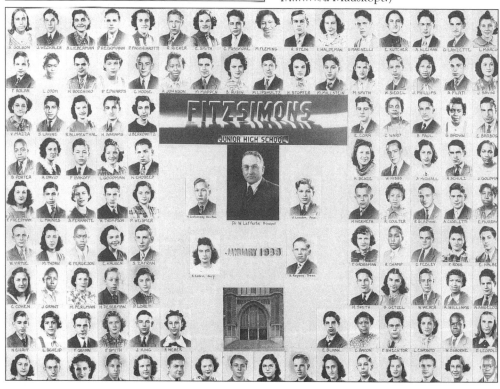

Rabbi Sholom Shneiderman, a visionary and leader in the field of Jewish education, created the Yeshiva Ohel Moishe at Thirtieth and Berks Street. South Philadelphia, only a ride on the route #9 trolley car, had the model Central Talmud Torah and Yeshiva Mishkan Israel as a counterpart. Yet, Yeshiva Ohel Moishe was different in that it offered dormitories for its students to live in a very strict Eastern-European outlook. Tragedy struck in 1951 when Rabbi Shneiderman was struck and killed by an auto on Roosevelt Boulevard after leaving the B' Street synagogue. The Kosher Butchers around the city buried him and then gave birth to the Philadelphia Talmudical Yeshiva in his honor. (Courtesy of Manfried Mauskopt.)

יב שלום צבי שניערמאן ז״ל

The Beth Jacob Schools originally started in South Philadelphia during World War II (1944) as a Jewish parochial school with courses taught by Rabbi Felix Freidfelder and Rabbi Aaron Popack. Eventually, branches were opened throughout Philadelphia. Rabbi Popack realized that bus transportation would help boost enrollment. Since he lived on Thirty-third Street, he arranged to lease space at the B'nai Jeshurun Synagogue, as the second branch of the first Jewish day school in Philadelphia. (The Philadelphia Jewish Exponent.)

The Hebrew Sunday School Society, dating back to the 1840s, had one of its many branches at the Kerem Israel Synagogue on Thirty-second at Morse Street. Ethel Becker, whose father, Rabbi Becker, led a congregation in Manayunk for the merchants on Main Street, went to visit relatives and teach classes. Formal education for girls was not encouraged, but in this community, peer pressure persuaded a very strict orthodox congregation to re-think this position. (Courtesy of Ethel Becker.)

Akiba Hebrew Academy was founded after World War II (1946) as an alternative to public secondary school. Jewish history and traditions had to be preserved according to Dr. Joseph Levitsky, Rabbi Elias Cherry, and educator Dr. Joseph Butterweck from Temple College. The small class of 40 students first met at the YMHA at Broad and Pine Streets. The school also followed the migration path of the Jewish population and moved to the B'nai Jeshurun Synagogue at Thirty-third and Diamond Streets in the Mansion. Neighborhood change forced the fledgling institution to move in 1955, and it then followed migration out of the Mansion to Wynnefield on the west side of the Schuylkill River. Today, it is an accredited institution in Lower Merion. (Courtesy of Bob Weiss.)

After school boys clubs were best characterized by the Ramblers organization. The Ramblers football team was well known for its athletic ability throughout the Mansion. Club houses were created by its members for social activities; boys and girls regularly met at the Santa Fe Club house at Thirty-fourth and Huntingdon Streets to discuss programs and to dance to records (78 rpms—the very big ones). (Courtesy of Stan Zafran.)

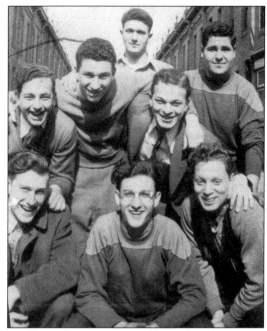

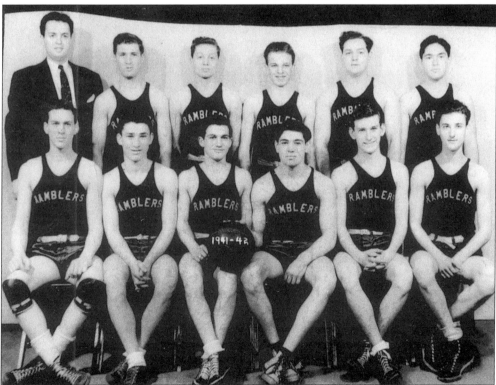

The Ramblers Athletic Club was very popular and attracted many athletes from Gratz, Northeast, and Central High Schools for its teams. The Rambler basketball team players were champions in Strawberry Mansion. The 1941 team included Joey Daniels, who does not appear in this photograph. (Courtesy of Ike Silverberg.)

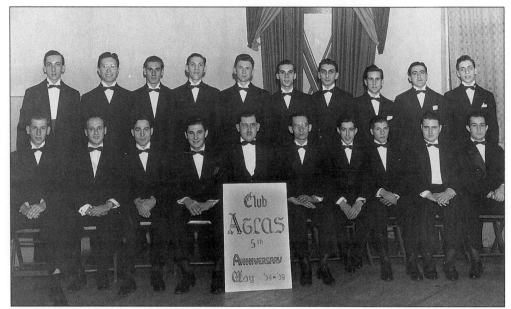

Club Atlas met next to the Beanery Restaurant on Ridge Avenue, near Thirty-second Street, in the mid-1930s. The boys held dances, parties, conducted a mock Passover Seder for the elderly in the community, and sported a baseball and basketball team. The members included Moe Glatt, Marty Savarn, Gerson Lichtenstein, Lenny Meister, Bob Lyons, Lenny Rosenberg, Jack Cherry, Leon Synder, Billy Coehn, Eddie Ring, Bernie Blum, Marty Lorber, Sammy Gonick, and Bernie Averback. (Courtesy of Charlie Clamper.)

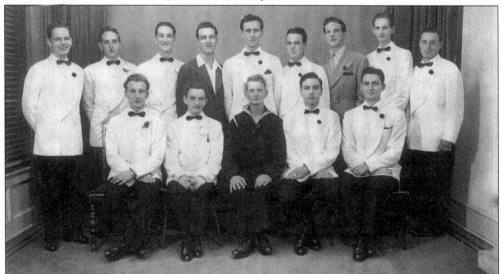

The Alpha Phi Club met above Segan's shoe shop on N. Thirty-first Street before World War II. Three groups of youth pledged their allegiance to Alphia Phi (friends forever). As one group grew older, they passed on the baton to their younger brothers. Some members included the following: Sid Connell, Ben Kushner, Saul Savitz, Max Brontstein, Manny Stone, Sonny Leblanc, Jay Richman, Ben Weinstein, Irv Sopinsky, Gene Robbins, Sam Charen, Irv Gold, Ed Silverberg, Bernie Silverstein, Jerry Blumer, Kurt Shumsky, Ed Itzenson, Ray Cohen, Jerry Paul, and Bill Abelove. (Courtesy of Henry Cohen.)

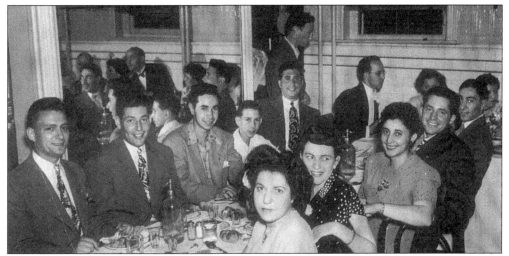

This photograph shows the Alpha Phi annual dinner at the famous Himmelstein's Restaurant at Fifth and South Streets, downtown, in 1943. Henry Cohen recalls when members were voted in by casting a white marble into a pot. If someone did not highly regard you, they would throw in a black marble; thus the term "black balled." The vote had to be unanimous. Other members included Ozzie Ostroff, Elwood Shore, Ben Weinstein, and Jack Hecht. (Courtesy of Henry Cohen.)

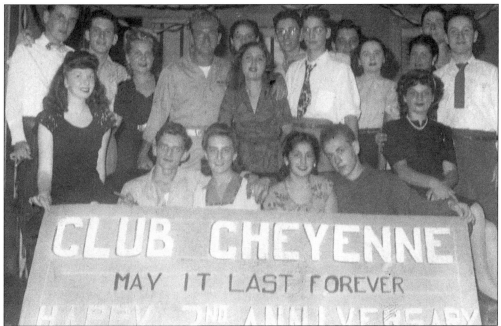

Club Cheyenne formed in the late 1930s and met at their clubhouse on Thirty-fourth Street, above Huntingdon Street. Members included Lenny Sternberg, Ed Schimmel, Larry Weiss, Fred Herring, and Sammy Volner. Many clubs existed in the Mansion, including Club Onyx (2930 Ridge Avenue), Club Harmony (Ridge Avenue between Thirty-first and Thirty-second Streets), Club Rhapsody (Ridge Avenue between Thirty-first and Thirty-second Streets), the Stag Club, and the Top Hat Club (where Harold Kaplan and his band played). (Courtesy of Bernie Seiger.)

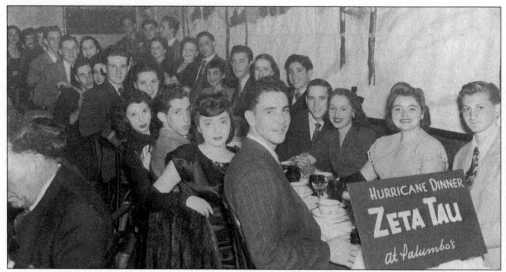

Sigma Alpha Rho, Zeta Tau chapter, was the Jewish fraternity for high school students of Strawberry Mansion. Zeta Tau was an active group that sold raffle tickets and had telephone runners at drugstores. The group included Manny Goren, founder to Revlon Cosmetics; Al Block, founder of Block Appliances and Jewelry; and Donald Gray, owner of a fuel business. Zeta Tau was in competition for members with the AZA or Arks and the YPL or Young People's League. (Courtesy of Manny Goren and Donald Gray.)

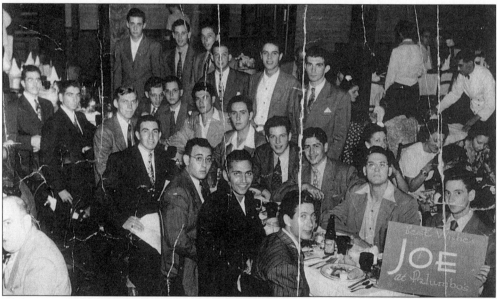

Club Essex, boys from Thirty-second and Cumberland Streets, originally met in Fairmount Park, in 1938 as a baseball team in the Fairmount League. Club Essex then moved to another club house at Twenty-ninth and Ridge Avenue, and was later located in several other places, including a huge apartment near the Cherry Pit Restaurant at Thirty-third and Dauphin Streets. Shown here, the boys celebrated Joe Levin becoming a doctor at Palumbo's. Some of the members were Nathan Brillman, Sidney Abert, Izzy Katz, Marty Bachman, Sol Katz, Joseph Levin, Abe and Hy Zalesznick, Leon Goodman, Sid Zaslow, Sam David, and Sideny Zeidner. (Courtesy of Sid Zaslow.)

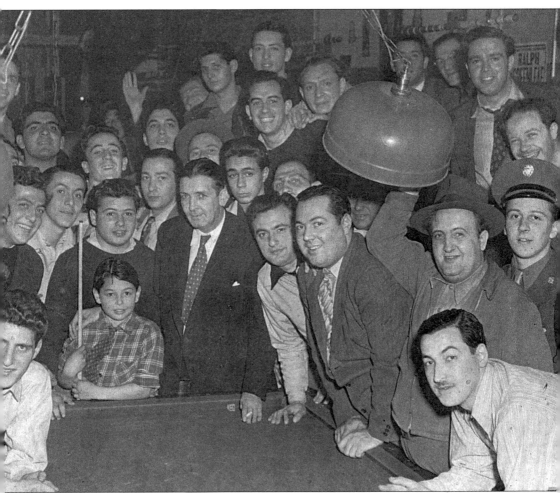

Jaffe's Poolroom, established in 1919 at Ridge and Dauphin Streets, served as the center of sportsmanship for many men from the Mansion. Poolrooms such as Bobbie's at Thirty-first and Berks, Portner's at Twenty-ninth and Gordon Streets, or Abe's at Thirty-first and Ridge Avenue were crowded with Jewish men who loved the noise and excitement of cue sticks and smoke-filled rooms. In the above photograph, nine-year-old Ronald Jaffe played against pool champion, Ralph Greenleaf and then went to Mitnik's sandwich shop to celebrate after the match. (Courtesy of Charlie Clamper.)

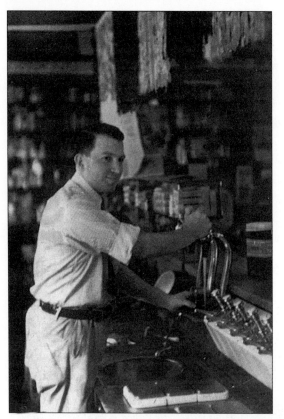

Morris Kushner, or "Doc Kay," served customers from behind the counter for most of his life. His clientele came from around the city to enjoy his famous chocolate soda at Kay's Pharmacy. From the 1920s to the 1950s, the drugstore catered to many people from their location where Ridge Avenue intersected Dauphin Street. Soda fountains were the mainstay of several businesses in the area, and they received their syrups from the local Rice Syrup and Supply Company on Ridge Avenue. (Courtesy of Paul Kushner.)

Kay's Pharmacy was a famous spot in the Manison. The beloved drugstore, which was run by the Kushner family, was demarcated with a large rounded sidewalk widely known as "the point." When World War II broke out, family members such as Sidney Kushner and Nathan Ziskin cooked for the boys and men in this photograph who were going overseas to fight. This was a wonderful spot to take a send-off photo! (Courtesy of Charlie Clamper.)

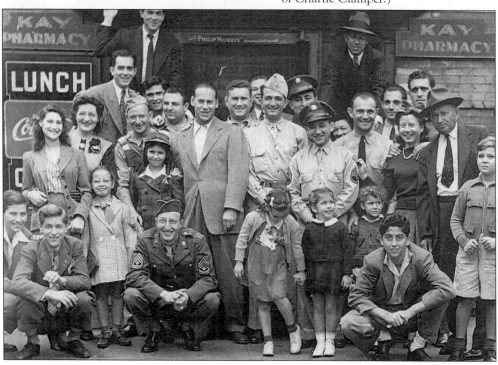

Milkman Harry Himmel, along with his horse, Ferdaleh, served milk products two times a day to Strawberry Mansion in the 1930s, often while reading the *Strawberry Mansion Gazette*. The horse understood every word Harry spoke—"*Her gay come ado*" (come over here) and "*shay dorstern*" (stay there)— as he made his rounds up and down the cobblestone streets. Harry supported his wife, Fannie, and their children, Seymour, Norman, Esther, Janice, and Pearl, for 30 years as an employee of Abbotts Dairies. (Courtesy of Pearl Himmel.)

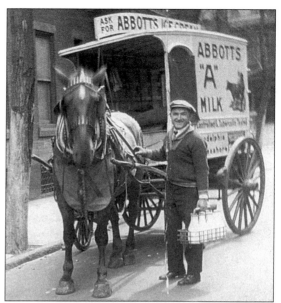

Mr and Mrs "Ben Hurs" scooped out memories to many children in Strawberry Mansion at their ice cream shop across the street from the Stokely school at Thirty-second and Berks Streets. Ben and Ida Horowitz came to Philadelphia in 1899 from Romania. The family settled in South Philadelphia at Seventh and Porter Streets, where they opened their first homemade candy store. The move to Strawberry Mansion took place in the 1920s. Ben Hur's ice cream was legendary and kosher! A peculiar dairy product was also available, known as YUM-YUM, and it was served in a cone-shaped paper cup. (Courtesy of David Harris.)

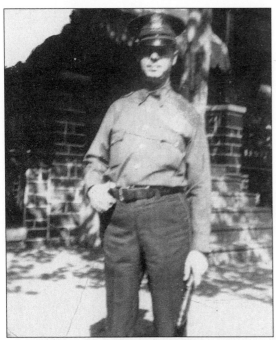

Jews joined the Philadelphia Police during the 1930s in record numbers, through political appointment. The Jewish uniformed officers formed a Jewish fraternity, *Shomerim*, in the late 1930s. Vic the cop walked his beat in the same neighborhood in which he lived (3128 Clifford Street) for many years. Vic patrolled the Thirty-first Street business district and schmoozed with the shop keepers. He was loved and respected for his fairness, especially since he dispensed justice with a neighborhood flair. A great achievement of this beloved man included selling the most War Bonds in his division during the early 1940s. (Courtesy of Myron Freidman.)

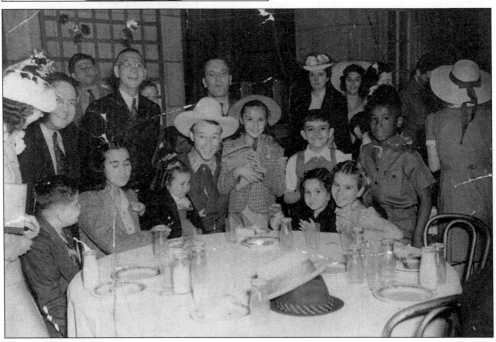

The Golden Slipper Club was a non-sectarian, charitable organization that catered to Jewish children and accepted many non-Jews into its programs—summer camps to all kinds of outings throughout the year. Celebrity Roy Rogers joined the children at the Strawberry Mansion Nursery School after shopping at Rodeo Ben's Western Wear store on Columbia Avenue in the late 1930s. Phyliss and Gail Allen, cousin Marilyn Shuben, and Joseph Smeyne joined the festivities. Note the little bottles of milk on the table for the children. (Courtesy of Phyllis Gross.)

As Jewish families worked harder and earned a better living, the need to have a domestic clean the house, store, or help raise children became a regular part of life. In Strawberry Mansion, Jewish housewives traveled to specific corners, where the trolleys let off black women (Thirty-first and Norris or Thirty-first and York Streets), to hire a domestic. The salary included their carfare, lunch, and 25¢ per hour in the late 1940s. Bessie Dowdy (pictured) worked for Molly's Gift Shop on York Street every Tuesday and Friday, while preparations were made for a day off and the celebration of the Jewish Sabbath, respectfully. (Courtesy of Maralyn Gardner.)

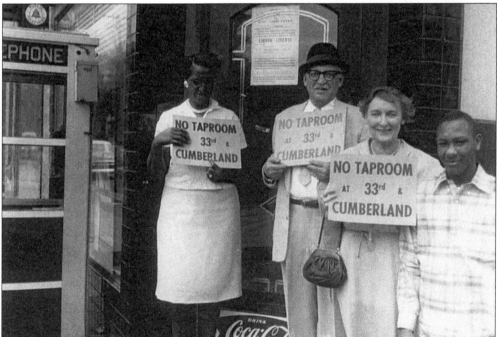

Hanna Silver, a Holocaust survivor from Germany, settled in Strawberry Mansion during the early 1950s. This remarkable lady continued to serve the community, even when the area had more black than Jewish residents. "White flight" did not stir Hanna in her fight to bring justice and action in building a sense of pride and purpose for the next inhabitants of the Mansion. She protested taprooms and her group stopped 21 out 23 attempts to open them in the area. Hanna, with the help of several agencies and the school board, secured one school bus to take 600 black children to Smith's playground in the summer on a daily basis. (Courtesy of Hanna Silver.)

The Bernie Axe Mansion, home of a successful manufacturer of house dresses (Thirty-third and Susquehanna Avenue), represented a cross road in time and location in the early 20th century. German Jews settled in Strawberry Mansion to escape the mass onslaught of 150,000 Eastern-European Jewish immigrants that spilled out of South Philadelphia. German Jews displaced the German and Irish population. Simultaneously, the dynamics of the new immigrant population had a direct transportation link, *vis-a-vis* the route #9 trolley that allowed upwardly mobile Eastern European Jews from South Philadelphia access to Strawberry Mansion in the late 1920s. (Courtesy of Allen Meyers.)

The Strawberry Mansion Hebrew Day Care Center (SMHDCC) originated in 1923 as a branch of its counterpart in South Philadelphia at Fourth and Snyder Avenues. The institution allowed working mothers to drop off their children at a safe location (2029 N. Thirty-third Street). Jewish Federation assisted with funding for this neighborhood venture. From 1947 to 1959, the Strawberry Mansion Recreation Association (SMRA) took over the Axe Mansion for its program. Joint programs ran for neighborhood children by both institutions until the closure of the SMHDCC in 1962. The building was leased by Congregation B'nai Jeshurun for a daily chapel, and the daycare center moved to Northeast Philadelphia at the Neighborhood Centre until the Paley Day Care Center was built in the mid-1960s. (Courtesy of the Philadelphia Jewish Exponent.)

The Junior Aide Nursery opened in 1952 through the genius of two 12-year-old girls—Rhea Longer and Judy Treatman. The idea was simply to baby-sit for children in the area, which could allow parents time for themselves in the summer. The Longer home, at 2637 Thirty-first Street, initially took in ten children. This is the same area that, only 30 years earlier, hosted the Strawberry Mansion Day Care Center at Thirty-first and Cumberland Streets before moving to the middle of the community at 2029 N. Thirty-third Street. Rhea conducted a summer camp and recalls her true role models were the parents in the neighborhood. Rhea considered the Mansion "the best place to grow up!" (Courtesy of Rhea Longer Applebaum.)

The Strawberry Mansion Recreation Association, founded in 1947, aided a growing young Jewish population with activities in the park across Thirty-third Street. Samuel I. Sacks, from Congregation Beth Israel, worked hard to find a home for the institution in synagogues and the former Axe Mansion, where a community center was added in the mid-1950s. The institution continued to operate until the early 1960s. The Golden Age Club migrated into South Philadelphia and found a new home at the YMHA at Broad and Pine Streets. (Courtesy of the Philadelphia Jewish Federation Day Care Services.)

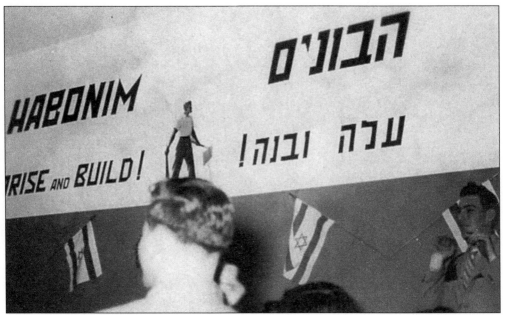

Habonim, a Labor Zionist group, had a chapter in Strawberry Mansion at the Menedel Shula at Thirty-first and Page Streets. Young people were recruited, educated, and sent to farm on the *kibbutzim* in Israel in the early 1950s. Norman Weiss met Saul Wachs from Chester at the Habonim Camp Galil in Ottsville, Bucks County. Fellowship meetings included dancing and singing popular Israeli songs. City-wide meetings were held at Gratz College. While Jewish people came from Europe during World War II to escape Hitler's Germany, others from the Mansion planned to settle in the Jewish state of Israel. (Courtesy of Norman Weiss.)

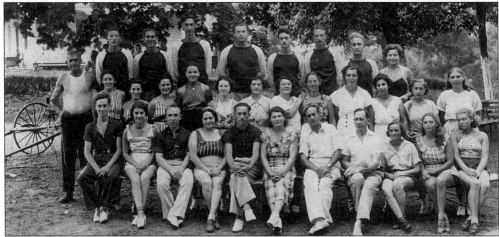

The Workman Circle Camp *Hofnung* or Camp Hope, located in Pipersville, Pennsylvania, attracted hundreds of children in 1936. Eddie Ring directed the sports program at the camp. Some of the campers included Anne Rudin, Hy Brodsky, Hy Chanen, Reba Blesshman, and Fannie Tropauer. Strawberry Mansion represented a microcosm of the entire Jewish community in America after the Depression through its diverse groups that represented many different ideologies. The community was diverse and had the ultra-religious, reform, liberal, orthodox, intellectual non-synagogue go-er, secular, socialist, and communist elements. (Courtesy of Lilian Ring.)

Six
Pictures in Fairmount Park

Fairmount Park, on the western boundary of Strawberry Mansion, was an extension of the neighborhood with activities year-round. The park was loaded with great venues that captured the interests of all ages. One could find children playing sports, music in the air from the Robin Hood Dell, or men playing chess. From early 1900 until the late 1940s, open trolleys ran in the summers. A collection of so many venues topped anything the shore or the mountains had to offer in the way of activities in one locale, which is what made this community a great place to live.

The Silverman family went to the park in search of relief from the heat in 1957. A mix of generations, including Lou, Rhoda, and Barbara Henkin; Gussie Koren; Iris, Gene, and Sarah Silverman; and Rose and Debbie Gross, ate and enjoyed each other's company. Jewish organizations held benefit picnics off Thirty-third Street on Sunday afternoons by selling strips of tickets for hot knishes, hot dogs, and soda for a 5¢ each. (Courtesy of Irv Silverman.)

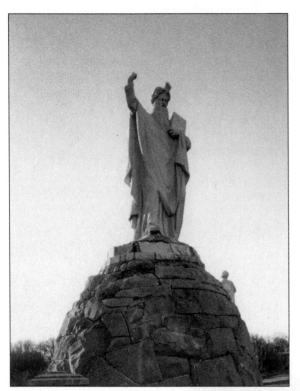

The statue of Moses on the west side of the Schuylkill River at the Parkside terminus of the Park Trolley was a favorite meeting place and picnic area. Jewish leaders from Strawberry Mansion organized a picnic under the watchful eyes of Moses in August 1947, with Ben Zvi, the future president of Israel, to discuss contingency plans for the outbreak of war with the Arabs over a Jewish homeland. (Courtesy of Allen Meyers.)

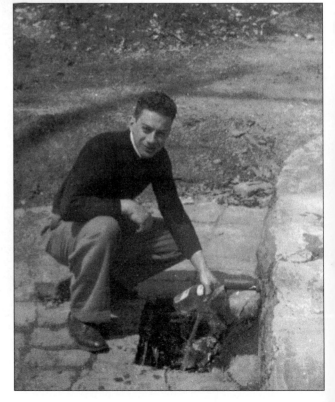

Ice-cold water was collected at the various springs in the park as a ritual that ushered in the summer. This spring, located within walking distance of the entrance to the Fairmount Park, was a favorite spot for Willie Diamond, cabinetmaker. The exact location, only 50 feet down the road from the large statue (above photo), was crowded with scores of people lining up to collect the cold spring water. Soda water vendors spread rumors that the springs were polluted in the early 1960s to aid their own sales. (Courtesy of Sylvia Green.)

Izzy Bellis, a champion tennis player, practiced on the clay courts near Thirty-third and Diamond Streets. He captured 83 titles from 1931 to 1936 while attending Central High School. Children and adults had many role models in this arena; they included Morry Bodginer, Sammy Handel, Morty Stein, and Buuny Stern. Izzy also played table tennis with Moe Glatt for the state championship in 1939. (Courtesy of Bunny Elaine Kolinsky.)

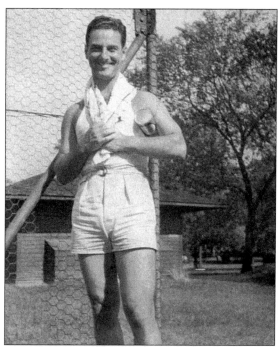

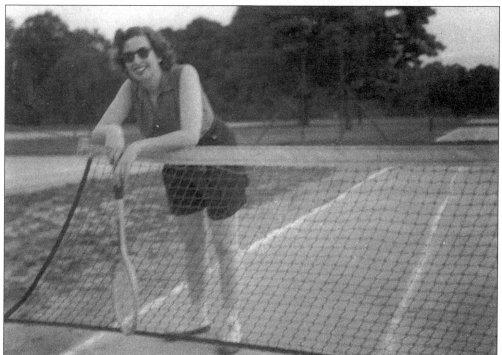

Female tennis champion Pearl Abramson played regularly at the Woodford Tennis Courts. In the early 1950s, Pearl played tennis with her friends, Florence Kahnwiess, Shirley Picker Ruldoph, Gussie Cantor Chudoff, and Irene Levin, on Sunday mornings after teaching Sunday School at Congregation Beth Israel at Thirty-second and Montgomery Avenue. (Courtesy of Pearl Abramson.)

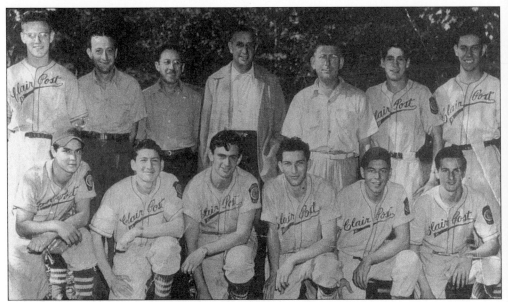

The 1944 Clair Post Baseball Team captured the essence of being young. The American Legion Post from Thirty-third and Fountain Street, which was mostly Jewish, sponsored neighborhood kids who were in high school. The members of the team included the following: Seymour Mednick, Jack Zelinger, Sonny Slosberg, Irv Silverman, Al Fagan, Allen Benowitz, Jerry Berman, Al Margolis, and many members of Club Atlas. Only a year later, when the boys turned 18, they were drafted into World War II. (Courtesy of Irv Silverman.)

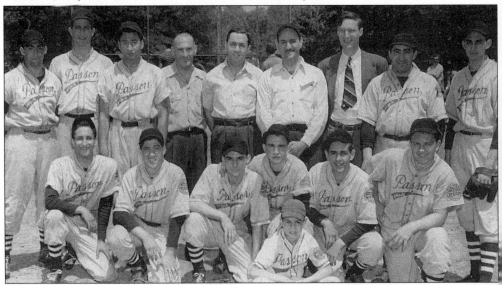

The Passon Whippets were sponsored by the Passon Sporting Store, downtown. The boys played in Fairmount Park, where nine baseball diamonds were maintained by a large ground crew from the Department of Recreation and Farimount Park Commission. Some of the players included the following: Lenny Factor, Mort Moskowitz, Al Schwartz, Al Herbach, Eddie Newman, Abe Schwartz, Joey Daniel, Sterling Devers, Irv Silverman, Freddie Oxman, and Stanley Small's pop. Eddie Newman's dad, an eye doctor at Thirtieth and Diamond Streets, came out to see the boys play. (Courtesy of Irv Silverman.)

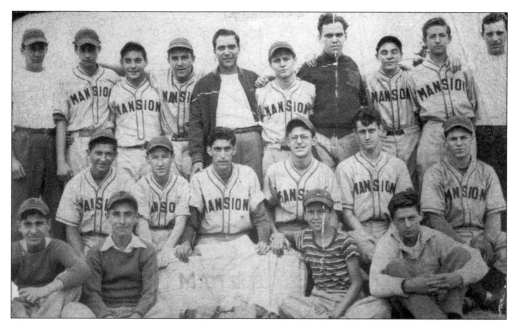

The Mansion team consisted of boys who graduated from the Philadelphia row-house games that included box ball, hand ball, step ball, wire ball, awning ball, and half ball. The guys who went through the different stages of competition belonged to various clubs, and each one of them had a baseball team. The Essex Club won the city championship in 1939, and the Mont Cliff Athletic Association, from Thirty-third and Montgomery Avenues, played against the Mansion team whether it was in the Pop Warner or Fairmount Park League. The Mansion team included Jackie Borish, Louie "Puggie "Herman, Meyer Stahl, Numie Dayen, Lou Feinberg, Marty Karn, Sol "Ippy "Spector, Willie "Pud "Konin, Charlie and Harry Shapiro, the Gaskon Twins, Mutty Brown, Hymie Gurovitch, Marty Goodman, Harry Kabo, Victor Katzer, and Jerry Rudick. (Courtesy of Pearl Himmel.)

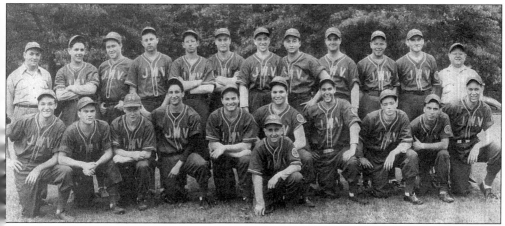

The Jewish War Veterans, Post #98, baseball team proudly boasted of its sponsor, Morris Goldstein, a local dentist on Thirty-second Street. Post #98 from South Philadelphia had members in Strawberry Mansion. The players included Jerry Berman, Moonie Weiner, the Auerbach brothers, Abie Schwartz, Henry Cohen, Mickey Myerson, and Buff Farber. They were part of the Industrial League from 1946 to 1949. Other teams, including Nate Ben's Reliable, came to know each other. (Courtesy of Henry Cohen.)

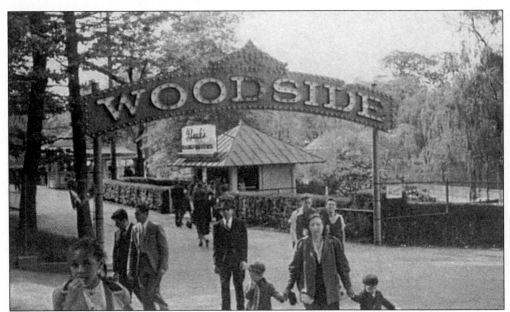

Woodside Amusement Park, was a wonderful place to take a date. Access to the amusement park from Strawberry Mansion was only a short ride on the Park Trolley or a walk across the Strawberry Mansion Bridge. At the park, a full day of activities, amusement rides, and just plain fun awaited, and lunch cost a nickel. Woodside Park closed in the 1950s as neighborhoods changed and populations shifted to newer areas of the city. (Courtesy of Lilian Ring.)

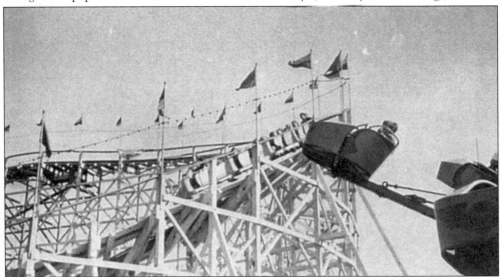

The rides inside Woodside Park made people's hair stand on end. Lilian and Eddie Ring went every summer in the late 1940s just to walk around and meet people they knew. Admission was free to those who knew someone who worked at the park or to those who saved five Breyer's dixie ice cream cup lids. The rides were famous throughout Philadelphia. They included the huge roll coaster known as the "Hummer," a smaller roller coaster known as the Wild Cat, the Whip, the Lightening Bug car ride, and the Chase the Duck mild water ride. How could one forget the kiddie rides such as the rocket ship merry-go-round that Wendy Gold Parris rode on as a child? (Courtesy of Lilian Ring.)

Crystal Pool, a resort venue with an Olympic-size swimming pool and Spanish motif with a red-clay tile-roofed clubhouse, catered to thousands of bathers in the summer. The Woodside Park fireworks on July 4th were visible from across the road. For a time in the 1930s, Jewish people, in particular, did not go to Crystal Pool, due to the fear of getting Polio. The summer of 1942 was a memorable one for Harry Freedman and Sylvia Morris who spent many days enjoying themselves with friends so close to home. (Courtesy of Sylvia Morris Wilder.)

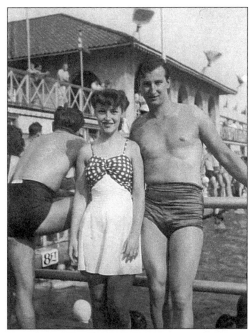

Scouts Triangle, on the west side of the Schuylkill River, held the key to many romances. After a wonderful day of folk dancing, taught by Al Merkis at the Strawberry Mansion pavilion near the Robin Hood Dell, couples gathered together to take the Park Trolley across the river to hike through Scout's Triangle. Sylvia Heindisch's parents, Meyer and Tillie (2635 Myrtlwood Street), allowed their daughter to go with the crowd that included Bronko, Blackie, Alvin Benoff (an Eagle Scout), Dollie, Shortie, Anna Bell, Victor, and Skeetz without worry. (Courtesy of Sylvia Heindisch Green.)

Left: Rhea and Harriette Longe enjoyed the fresh air and sunshine in 1944. (Courtesy of Rhea Longe Applebaum.) *Center:* Philadelphia's culverts, man-made water runoff channels, were legendary throughout the city. This one in Fairmount Park was converted into a slide by Gerson and Hannah Lichenstein and Lilian Ring. (Courtesy of Lilian Ring.) *Right:* Barry and Warren Abrams stopped for water after visiting their favorite horse, "Tony Boy," part of the mounted patrols in the park, in 1941. (Courtesy of Barry Abrams.)

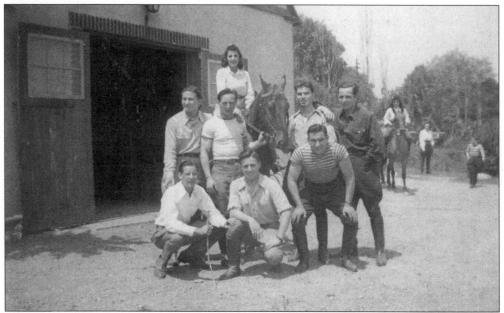

The riding stables in Fairmount Park, which were favorite sites for friends to fool around, included Alexander's Riding Academy near Gustin Lake. Al Handel, Al Levin, Marty Ostroff, Yacey, and Goldie Cantor posed for a picture in the summer of 1941. (Courtesy of Alan Gofberg.)

Left: Boat House Row was a family resort, and boys like Mort Shapiro went for canoe rides on the Schuylkill River near the public pavilion below the Strawberry Mansion Bridge on East River Drive. (Mort Shapiro.) *Center:* Best friends laid out on blankets behind the baseball diamonds off Thirty-third Street, in the area known as the "Horse Shoe." (Courtesy of Meyer Shulik.) *Right:* Daddy's little girl, Wendy Gold, ice skated with her dad, Newton, on Gustin Lake in the late 1940s. Newton Gold owned the Austrian Gas Lamp Company at 140 North Second Street that manufactured old-fashioned gas mantels widely used in homes at the time. (Courtesy of Wendy Gold Parris.)

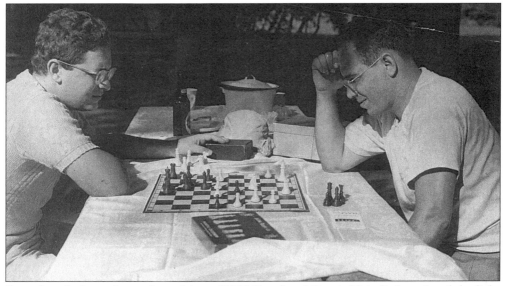

Great Jewish chess players, Larry Miner (2500 Napa) and Bernie Heindisch, enjoyed the light summer breezes under the shade of trees in the park and played from early morning until twilight in this 1954 photograph. The park tables were very comfortable, and when the boys were tired, they laid down on the green park benches made of thick wooden slates and molded pebbled stone concrete for a short snooze. (Courtesy of Sylvia Hreindisch Miner.)

Singing in the park was another great pastime for young men and women. Besides, the neighbors could not hear Meyer Stahl, Numie Dayen, Willie "Pud "Konin, Sidney "Duffy" Friedman, Sol "Ippy" Spector, Louis Herman, and Jackie Borish shout their tunes. These guys always received the attention of the ladies who strolled on the "Thirty-third Street Promenade," which extended from Columbia Avenue to Dauphin Street. The boys even serenaded newly married couples who came to the park to have their wedding pictures taken outdoors in the late 1930s. (Courtesy of Pearl Himmel.)

Strolling on Thirty-third Street, inside Fairmount Park along the circular concrete pathways, are memories that will never die. The baby carriages were lined up on Sunday afternoons in the late 1940s and early 1950s, just like trolleys. Proud parents, like Jean Baron, took their bundled-up children in the "coach" for a pleasant walk around the "Horseshoe" that ringed the baseball diamonds at Thirty-third and Dauphin Streets. Young married women exchanged news with their girl friends who they met in the park with the children. (Courtesy of Jean Baron.)

Seven
THE POWER OF FAMILY

Families provided the anchor for the Jewish community of Strawberry Mansion. The Jewish immigrants from Eastern Europe laid claim to this area and settled in the Mansion during the 1920s, one generation after the German Jews arrived. The value system they helped to establish spread and grew into one communal family that was connected for blocks. People brought relatives to live on the same blocks they lived on, or around the corner, by secretly bidding on real estate before it was put up for sale to the public. Families endured hardships and adverse weather conditions, celebrated the good times, and supported each other in times of sorrow.

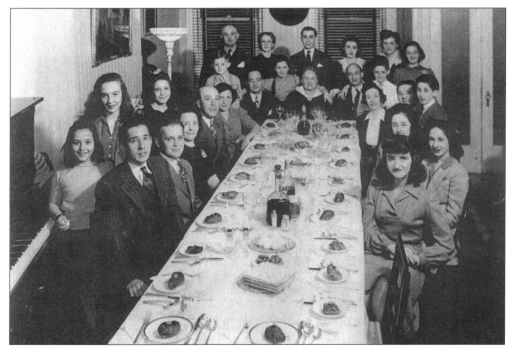

A family Passover Seder in the home of Lilly and Jake Simon (N. Thirty-third near Diamond Street) gathered different branches of the family tree in the late 1930s. Marvin, Alan, and Pearl Schluger; Sadie and Leon Schluger; Elsie Max; Mary and Charlie Carlson (from the furniture business on South Street); and Roth, Marty, and Frances Simon all celebrated in the Jewish calendar year that marked freedom from Egyptian bondage during biblical times. Families celebrated by buying new clothes for the children and painting their kitchens bright colors. (Courtesy of Ethel Simon.)

Left: An engagement on 3217 Page Street took place in 1954. Milton Goldman met Marcia Brod at a *shul fight,* or Sunday evening dance, at Temple Sholom in the Oxford Circle section of Northeast Philadelphia. *Right:* The proposal for matrimony took place at 2438 N. Patton Street for Irv and Iris (Gross). The Strawberry Mansion couple courted each other at Ben Hur's Ice Cream Parlor. Iris' parents, Rose and Izzy, adored Irv. (Irv and Iris Silverman.)

Childhood sweethearts Stan Kligman and Edith Toizer did everything together since their teens. Stan delivered the *Evening Bulletin* on Corlies Street when he met Edith. The couple was inseparable and often rode bikes through the park. Stan's parents, Ben and Frances, approved of the union. Stan often took Edith to Riverview Beach Amusement Park on the Wilson line that ran down the Delaware River to Marcus Hook. The couple was married by Rabbi Alexander Levin after graduating from high school, in 1958. (Courtesy of Stan and Edith Kligman.)

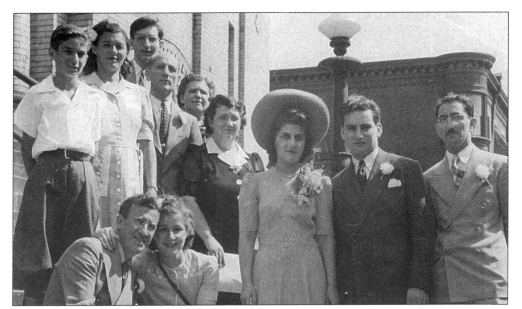

Wedding pictures on the steps of Beth Israel were typical for people in the Mansion. In 1941, Julian Kobler and Ruth Shagen were married in a house on Clifford Street. The bride and groom asked their wedding party of Leon Lieberman; Debbie Gould; Lillian, Max, and Ed Kobler; and Cecil, Paul, and Rubin Gould to meet on the steps of Beth Israel Synagogue for a wide-angle wedding photo. (Courtesy of Ed and Julian Kobler who are brothers forever!)

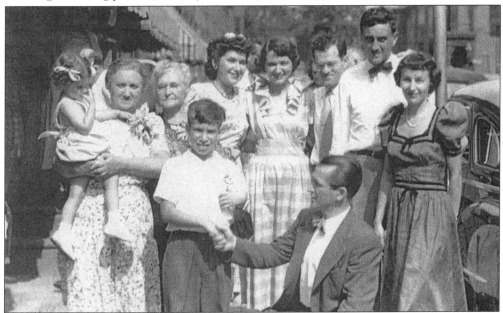

An old-fashioned house wedding at 2947 W. Norris Street turned into a neighborhood event, with the whole block celebrating, in this 1949 photograph. Relatives in attendance of Louis Matkoff and Shirley Dubin included Jack, Lorraine, Madeline, and Helen Dubin; Harry Matkof; and Robert and Betty Mac Millian. Traditions established many years earlier in Europe called for a wedding in the girl's house. This wedding was carried out by Rabbi Meyer Finklestein from Congregation Beth Israel. (Courtesy of Louis and Shirley Matkoff.)

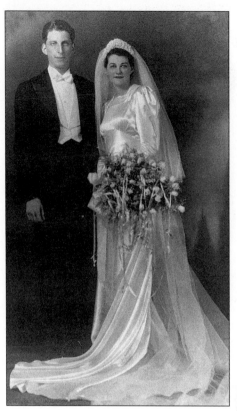

Synagogue weddings took place more frequently after World War I. Eugene Appell and Rose Kerner were married in the 1930s by Rabbi Barzel at Congregation B'nai Jeshurun. Rose's parents came to America from Romania by escaping in a hay wagon to avoid the pogroms in their village. The Kerner family ran a dry goods store at 1626 Germantown Avenue in North Philadelphia. (Courtesy of Helen Oxman.)

Fannie and Hyman Atlas both came from Russia and settled in North Philadelphia at Front and Diamond Streets. After their wedding in 1918, the couple moved to 1956 N. Twenty-ninth Street and gave birth to two daughters, Doris and Rose. (Courtesy of Doris Atlas Barnow.)

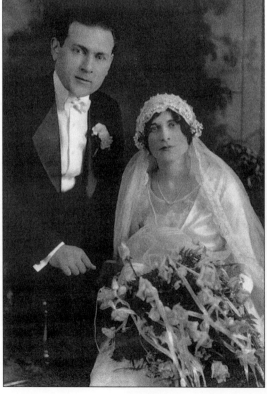

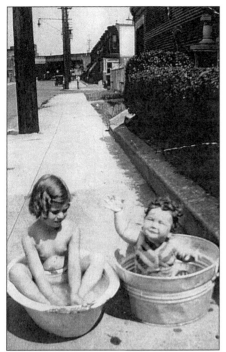 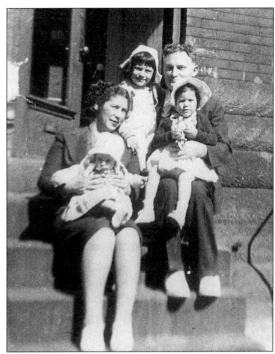

Left: Sidewalk greetings from Phyllis Lewis and cousin Marilyn Brown Shubin were given to neighbors in the usual fashion during the summer months of 1935. Allen and Hannah Lewis came to the Mansion and lived at 3230 W. Norris Street. Allen managed the Park Movie Theatre at Thirty-first and Diamond Street. (Courtesy of Phyllis Allen Gross.) *Right:* The row house steps at Thirty-first and Oxford Streets was a perfect perch for a family photo of Rose and Jacob Smith, who came to the Mansion from Russia in the late 1930s with their children, Arlene, Sonya, and Anita. (Courtesy of Arlene Smith.)

Strolling with baby coaches was a common practice. The World War II baby boom had a major franchise in this community. It was common to see 10 to 15 people pushing baby coaches on the same block. Al Schwartz and his wife, Thelma, schmoozed with neighbors. (Courtesy of Al and Thelma Schwartz.)

Left: A young boy's first visit to synagogue with his dad was a treasured memory. In the late 1940s, Carl Hoffman and his dad often went for walks in the park and then visited the B'nai Jeshurun Synagogue. (Courtesy of Carl Hoffman.) *Right:* Invitation to a bris was a time-honored occasion. The circumcision, a covenant between Jews and their religion, brought families together. Harriet and Leonard Gilbert with their son, Michael, join in the festivities for George Cohen son's bris on 1800 N. Natrona Street. (Courtesy of Harriet Gilbert.)

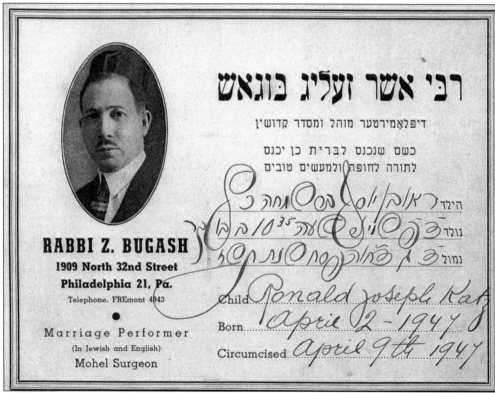

The bris certificate in America became the second most valued piece of paper, after a marriage license. Rabbi Zelig Bugash kept busy performing circumcisions every day of the week as a result of the population explosion after World War II. A bris even takes precedence over the Sabbath as the rejoicing takes place in the home. (Courtesy of Ron Katz.)

Left: Sisters growing up in the Mansion, Roberta and Susan Rubenfein, posed outside their grandparents home near Twenty-eighth and Lehigh in 1951. (Courtesy of Roberta Matz.) *Right:* Eva and Albert Browne lived at 2503 N. Thirty-first Street after arriving in America from Russia and Palestine. The family included nine children; Joe, Sarah, Rose, David, Gladis, Fred, Ruth, Donald, and Lawrence all became teachers, doctors, and lawyers. Albert toiled at the Sklaroff smoked fish company on Delaware Avenue. (Courtesy of Ruthie Browne.)

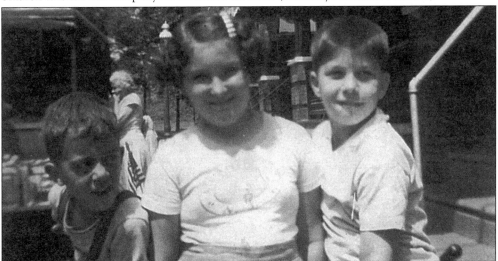

Who can forget the fruit and vegetable Huckster who came around with a horse and wagon singing his lungs out about the price of strings beans, 15¢ a pound; Jersey tomatoes, big and ripe; and large cantaloupes, 2 for 39¢? Carl Hoffman and Johanna and Allen Young bask in the summer sun while enjoying fresh cherries at Thirty-second and Page Street. (Courtesy of Carl Hoffman.)

"Sam the Knish Man" celebrated his son's bar mitzvah at the Roney Plaza Ballroom at Broad and Glenwood Streets. The proud boy posed for a special moment with his parents and grandparents in this late 1950s photograph. No expense or detail was overlooked in the celebration of this rite of passage, especially the three-tier bar mitzvah cake. (Courtesy of Ron Katz.)

The bar mitzvah reception was a big party for the entire neighborhood and superceded a wedding reception in many families. Neil Solbotkin's bar mitzvah took place at the Majestic Hotel on North Broad Street in 1952. The men who hung around Kay's Drugstore joined in the celebration. They included Mr. Chesney, owner of the Kozy Corner Luncheonette; Leo Harris; the London Brothers, the biggest flower business in Philadelphia; Paul Roth, owner of a pool hall on Ridge Avenue; the Seltzer Brothers, who sold sundries; and Neil's dad, Irv. (Courtesy of Paul Kushner.)

A girl's birthday party brought children together for ice cream and cake at Rhea Longer's house, in 1950. The invited guests were Yvette Mosko, Ilene Lefko, Sandy Graitzer, Marilyn Chackler, Rosalyn Needleman, Anita Berkowitz, Judy Treatman, Annette Weinberg, Betty Rockliss, Anita Wishnetz, Marsha Bresner, Carol Gubin, and Rhea and Harriette Longer. (Courtesy of Rhea Longer Appelbaum.)

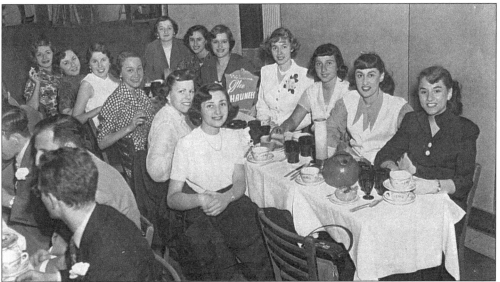

If the boys could organize a club then the girls could do it too! The Shawnee Girls Club competed with the KLK (Kute Little Kittens) for members in the Mansion. The girls met in homes, played records, planned socials, and raised money for jackets to wear on dates. The girls, including Elaine Blum, Fannie Axelrod, Harriette and Marion Braverman, Gladis Alkis, Elaine Snyder, Penny Krusen, and Selma Portner, held their affairs at the Latin Casino on Walnut near Broad Street, which was owned and operated by a family from Strawberry Mansion. (Courtesy of Maralyn Gardner.)

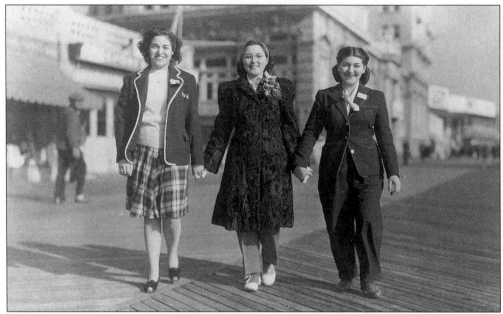

Strolling the boards down the shore in Atlantic City was shared by mothers, daughters, and aunts. Minnie Berman, Gladis Rosenberg, and Rhea Owrutsky attended a national Hadassah convention in 1944. The attraction of the Miss America contest, held every year for decades in Atlantic City around Labor Day, held special meaning in the late 1940s, when Bess Meyerson, with ties to Philadelphia, won the crown. (Courtesy of Rhea Shils.)

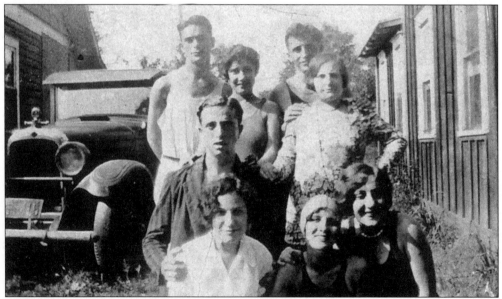

Blackwood Lake was a trip to the country and an outing to a lake that made people so happy they lived near the shore. The trip across the then new Ben Franklin Bridge (built in 1926) into New Jersey was a treat all its own. The fun began when you passed lake after lake along Rt. #130, the White Horse Pike, or Black Horse Pike. Jewish people like Yetta, Max, Marcus, Israel, Lilyan, and Becky Baratz rented cabins at Blackwood Lake for a week in the 1930s, to relax, swim, fish, hike, and boat in the country. (Courtesy of Marilyn Ziskind.)

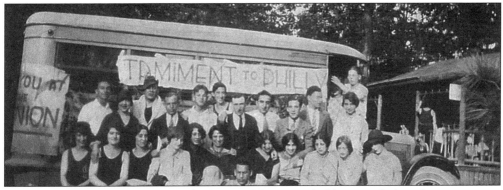

The singles scene at Tamiment in the Pocono Mountains held a special place for many young people from Strawberry Mansion. Whole busloads of adults went on excursions to the mountains in the 1920s. Romance was everywhere in the Poconos, and Harry Leib found his future wife in 1926 while eating, bathing, and row boating. Harry and Kitty Kolinsky became newlyweds two years later, in 1928. (Courtesy of Elaine Bunny Kolinsky.)

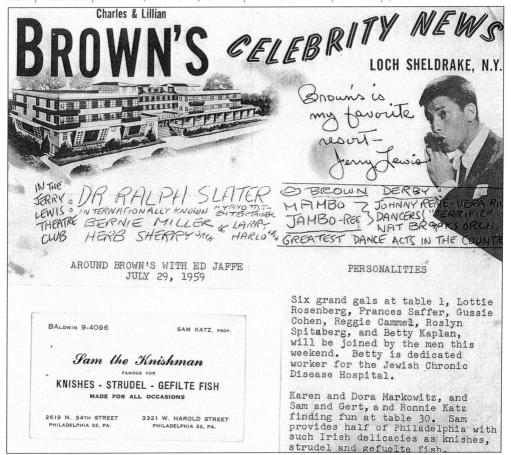

Family vacations in the Catskill Mountains, were enjoyed by many people from the Mansion. Jerry Lewis's (the famous comedian and entertainer) family owned Brown's family resort in the Catskill Mountains above New York City. Families were treated like royalty, especially if Mr. Lewis knew you were a celebrity—like Sam the Knish Man. (Courtesy of Ron Katz.)

Being at home with the radio on Sunday mornings, listening to Nathan Fleischer delivering the world news, was a real pleasure. The greatest symbol of progress in the 1930s and early 1940s came when a household traded up to a console radio made of beautiful wood in various shapes and sizes. The torch light, with its arching rays of light on the walls and ceilings, provided a warm atmosphere for Thelma to sit and relax, too! The children and parents sat in the same room doing different things while the radio informed and entertained its audiences before the arrival of television. (Courtesy of Thelma Schwartz.)

Thanksgiving Day became an American Jewish tradition after the Depression. Jewish families assimilated into American life by adopting and celebrating its holidays. Several factors lent themselves to this transition in Jewish life, which included the fact that the turkey could be slaughtered Kosher! The Trainor family, Willy Diamond, Larry Miner, and lots of friends celebrated together as an extended family, thankful that World War II was over. (Sylvia Heindisch Miner.)

Eight
THE STREETS AND HOUSES WE LIVED IN

People chose Strawberry Mansion as a residence for many reasons. The convenience of transportation to the downtown, connections to South Philadelphia, plus great shopping districts added a touch of familiarity to the close-knit community called the "Mansion." The housing stock of two-, three-, or four-story brownstone row houses with outdoor porches varied according to one's economic means. Yet each person admitted with pride when telling someone they were from the Mansion! Family living meant a great deal to the 50,000 Jewish immigrants who gathered from around the world in the Mansion during the 20th century. Strawberry Mansion people loved their neighborhood and living quarters so much that they moved around the community living in 2, 3, and sometimes 4 houses.

Proud *zayde* (grandfather) with his grandchild, Meyer Corsun(sky), a life-long carpenter, was always building things. Meyer and his wife, Jennie, conducted Passover Seders in their home at 3206 Clifford Street for the entire family until his death in 1955. Pride, joy, and patriotism marked Meyer's life as an important community leader and *gabbai* (officer) at Congregation Beth Israel at Thirty-second and Montgomery Avenue. (Courtesy of Carl Hoffman.)

Left: Thirty-third and Cumberland Street for 4-year-old Harold Weinstein, bundled up in a snowsuit and riding a tricycle, was heaven on earth in 1944! Family members lived at 2564 Corlies Street. Harold was born on the same day as his cousin, Myron Bender, March 3, 1942, and both were delivered by Dr. Barr. (Courtesy of Harold Weinstein.) *Right:* Marcia Diamond loved her pony and wished that she could ride it to school even if the pony belonged to the neighborhood photographer. Note the fancy ironwork on basement windows with its flower details. (Courtesy of Marcia Diamond Garb.)

North Thirtieth and Huntingdon Street, covered by cobblestones, served as a major obstacle for young Marvin Green. One could only think what was going through Marvin's mind when Frank's soda water was delivered from the old truck to the corner store! Marvin crossed that street years later and became a chemical engineer for the New Jersey Environmental Protection Agency. (Courtesy of Marvin Green.)

North Thirty-fourth Street was a great place to trick-or-treat on Halloween 1957. Kathy Miner, the daughter of Sylvia and Larry Miner, joined hundreds of children in the community by dressing up and going house to house for candy! The participation in Halloween activities—a holiday with religious overtones—is another example of assimilation by American Jews. (Courtesy of Sylvia Miner.)

This home, at 3217 Page Street, had a real fireplace and warmed the heart of Marcia Brod, in the arms of her uncle, Lou Spikol, in the late 1930s. The Brod residence was a favorite gathering place for the extended family that numbered 60 people living in the Mansion. (Courtesy of Marcia Brod Goldman.)

Left: Ron Katz is pictured with his mom. Links to other Jewish neighborhoods such as Feltonville, West Oak Lane, or Wynnefield were made via trolley cars, which had housing stocks that looked the same. The "straight through" row houses, built in the 1920s, came with an open porch that was converted into a sun room by enclosing the front porch. (Courtesy of Ron Katz.) *Right:* Gertrude Kuerschner-Neuman, pictured with her two children, came to America during the 1940s and found housing plentiful even though, by Europe's standards, the houses were small. (Courtesy of Evelyn Beer Feinberg.)

The back yard at 3300 Harold Street was a completely different world for the Katz family, who supplied delis and restaurants with fresh knishes and strudel. The wooden party fence separated people from their neighbor and gave people a sense of privacy. Usually, there was an alley way for the men to pick up the garbage every week. (Courtesy of Ron Katz.)

Left: North Thirty-second Street holds many memories for William Spikol. (Courtesy of William Spikol.) *Right:* The house at 2603 North Thirty-first Street looked like many of the homes that stood proud in the Mansion. Dora Fishbein grew up in a house that had had a marble stoop and trim work like houses at Fourth and Wharton Streets in South Philadelphia. The cellar, reserved for the coal bin and furnace, was unfinished and had a dirt floor. (Courtesy of Dora Fishbein Toll.)

Below Diamond Street, Thirty-second Street gave young people an open window to the world. Accessibility to the Park Movies, the Route #9 trolley, and the park came with the territory for the Ozer girls, Molly and Lillian. Samuel Ozer, the girls' grandfather, owned a grocery store in the middle block that was a favorite hangout during the summertime. (Courtesy of Alan Gofberg.)

Sylvia Miner picks up her son, David, from his playpen in front of their house at 2530 N. Thirty-fourth Street. Strawberry Mansion shaped us and molded our outlook on life, recalls Sylvia. The working class person, living in the upper end of the Mansion, became affluent in the 1950s as wages rose, and many people attained an annually salary of $10,000! No matter how much money one has accumulated, the Mansionite looks back on their experience with the mindset that it made us who we are, and our past was really our future. (Courtesy of Sylvia Miner.)

An apartment at Twenty-ninth and Diamond Streets was the home of the Mendelsohn family. French doors led to a large vestibule where toys, including tricycles and red wagons, were stored for Ruth as a child, which was convenient for her mother, Rose, to *schlep* outside. Nathan chose this location because he was a cop at Twenty-eighth and Oxford from 1938 to 1945. (Courtesy of Ruth Mendelsohn-Gurman.)

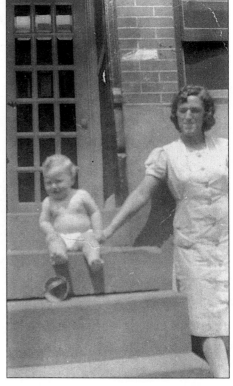

Left: The home at 3132 French Street had all the amenities of a grand mansion, including large windows that had large screens to keep the flys out! Eva Achter-Itzenson had a bench specially made in the 1930s. (Courtesy of Ed Itzenson.) *Right:* Napa Street was a special location with great neighbors dispensing knowledge about the old country. Rose Green, who sat on the benches to socialize every night, found time for her nephews who came from around the corner to visit frequently in the early 1940s. (Courtesy of Marvin Green.)

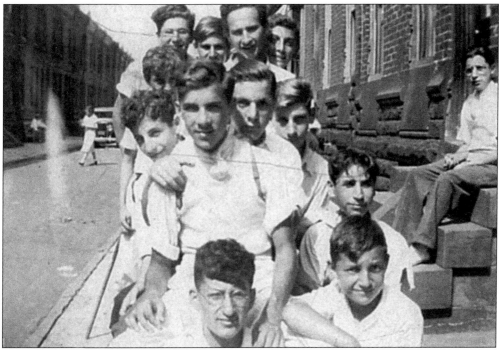

The homes of the kids who formed Club Atlas were like many in the Mansion—two-story brownstone row houses on a narrow street. Cars were only allowed to park on one side of the street, and the other lane was for traffic to pass. Children of the Mansion, including Gerson Lichenstein, Eddie Ring, Jackie Cherry, Herman Poritzky, Albert Meritz, Bernie Savran, and Lenny Meister, loved to joke, play buck buck, stick ball, and enjoy each other's company during the Depression. (Courtesy of Lilian Ring.)

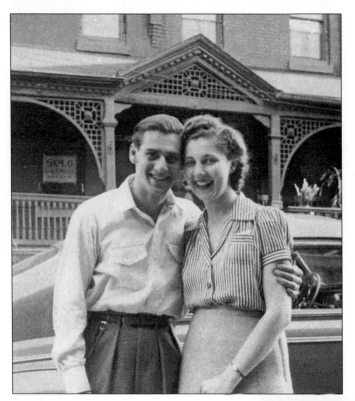

The setting for this photo was 3200 Monument Street, almost 60 years ago, with Eddie Ring and his finance, Lilian Evenstein. Boys and girls met and became friends for life in the Mansion. Three couples, who all knew each other from childhood, married within three weeks of each other. Sammy and Sylvia Gonick were married August 10, 1941; Bea and Bernie Auerbach tied the knot the following weekend, August 17, 1941; and Eddie and his sweetheart, Lilian, were married by "Rabbi" Gershon Brenner (related to comedian David Brenner) on August 24, 1941. (Courtesy of Lilian Ring.)

Shirley and her brother, Jack Dubin, supported their *zayde* with a great deal of love! Israel Grebel, a vest maker, adored his grandchildren. (Courtesy of Shirley Dubin Matkoff.)

Nine
WORLD WAR II PHOTOS

The Jewish men and women of Strawberry Mansion joined the rest of America from 1941 until 1945 in establishing a long-lasting and just peace throughout the world. Hundreds of Mansionites laid down their sewing needles, work aprons, and tools and ultimately paid the supreme price of freedom with their lives.

The disruption of daily life was strongly felt. A group of mothers who lived near Ridge and Dauphin Streets formed the 127th Fighting Brigade as an active support group for their children serving overseas. They raised money selling war bonds, held parades and picnics, and supported each other when the Western Union courier had news of a person killed in action.

Eddie's Barber Shop on Ridge Avenue, near Thirty-second Street, became the hub of information for Strawberry Mansion residents on the war effort and its casualties. Eddie Clamper raised money for soldiers to buy cigarettes so that they could smoke as much as they wanted. He served another purpose by building support and morale for men entering the armed services, knowing they had a home command post ready to assist in anyway it could. (Courtesy of Charlie Clamper.)

 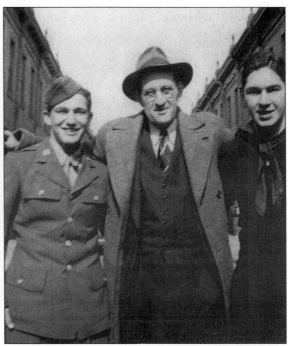

Left: Franklin D. Roosevelt visited Strawberry Mansion in the 1930s in an open touring car that stopped at the Thirty-third Street Shul, where the whole congregation of B'nai Jeshurun emptied out of Yom Kippur service to recite the prayer for the President. (Courtesy of Ed Itzenson.) *Right:* On Myrtlewood Street, benefactor Alex Block of the Ramblers Athletic Association threw his arms around some of his boys—Abe Seidman and Phil Schwartz—who proudly served in the armed services. (Courtesy of Ike "New Yorker" Silverberg.)

War Ration Books were issued by the U.S. government to prevent hoarding provisions and to keep prices from soaring beyond what citizens could afford for gasoline, beef, sugar, coffee, and other essentials—including chewing gum. Chewing gum contained rubber residues, and rubber was needed for the war effort. Jerry Green remembers having to divide his stick of gum into 5 pieces to last all week! (Courtesy of Harold Weinstein.)

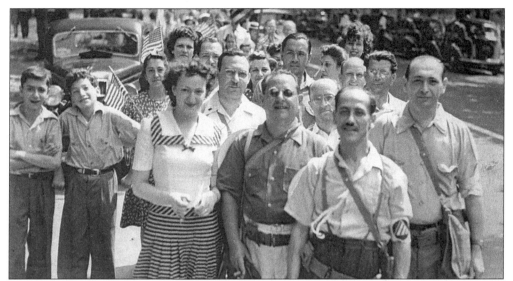

A war rally led by air-raid wardens, an arm of the Civil Defense network, took place on Thirty-third Street, Memorial Day 1943. The air-raid wardens worked closely with police to protect the community against possible enemy attacks from the coastline. Three men from each block walked their street every night to ensure that trolley cars turned out their lights and neighbors had their shades drawn. When Harry Kelkey received news of his son being killed in action, the air-raid wardens organized the Milton Kelkey Jewish War Veterans Post. (Courtesy of Charlie Clamper.)

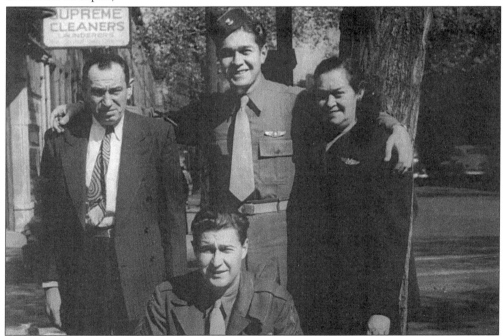

Service heroes Marvin and Arthur Goldberg pose with their parents on tree-lined Diamond Street, where the family ran a restaurant.. Arthur served in the U.S. Army across Europe and saw action in the Battle of the Bulge. Arthur had a dog, a prize for fighting so hard, shipped to Philadelphia via American Express in 1946. (Courtesy of Arthur Goldberg.)

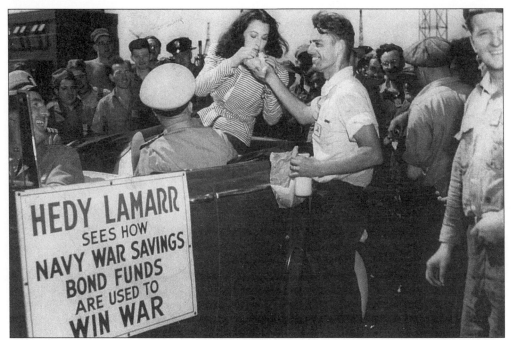

Rewards of the World War II effort included greeting the movie stars that came to Philadelphia. Isadore Weiss, Gilbert Yanowitz, and John Stern took time out to meet Hedy Lamarr at the Naval Shipyard in 1944. (Courtesy of Norman Weiss.)

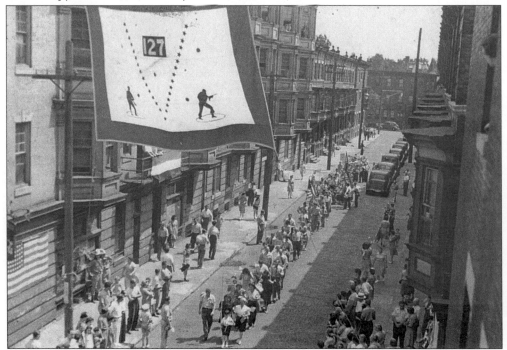

The 127th Fighting Brigade mothers drew attention when they marched down Natrona Street. After World War II, the community put up a memorial for the fallen heroes from the Mansion at Thirty-third and Columbia Avenue. (Courtesy of Charlie Clamper.)

Al Handel survived World War II as a POW in Europe. His *bubbie* gave him the biggest hug at his 3144 Diamond Street home, where he lived and grew up with his brother, Sammy, the tennis champ. (Courtesy of Pearl Himmel.)

The FD and IS Clair American Legion Post, at Thirty-third and Fontain Streets, held dances, picnics in the park, and fundraisers for families in need during World War II. This predominantly Jewish American Legion Post elected Jewish officers, including Marshall Perch, Judge Rosen, and Jack Briskman. Also pictured are invited guests, Marilyn, Anne, and Joannie Briskman, and Helen and Shirley Dubin. A World War II memorial was erected on Thirty-third Street near Columbia Avenue. (Courtesy of Shirley Dubin Matkoff.)

Left: World War II service couple Murray Root and Lilian Ozer both came from Thirty-second and Diamond Streets. Murray received the Distinguish Service award, and Lilian worked at the Naval Supply Depot. (Courtesy of Alan Gofberg.) *Center:* Muttie Neidich faked his age to enlist into the Navy and was aboard the USS *Samuel B. Roberts* when it sank in the Philippines. Muttie survived by holding onto a floating piece of wood for 56 hours. (Courtesy of Bernie Auerbach.) *Right:* Dick Proitzky served aboard the USS *Enterprise*. Without regard for his own safety, Dick rescued several men from a burning compartment of the ship. (Courtesy of Bernie Auerbach.)

World War II hero Max Berger survived the Battle of the Bulge, came home to visit with his wife, and shipped out for action at Omaha Beach. When Max returned from the war, he joined the United States Postal Service. (Courtesy of Jean Berger and his daughter, Marsha.)

Left: Officer Jerry Cornfeld joined the U.S. Army against the wishes of his friend, Eddie the barber. (Courtesy of Charlie Clamper.) *Center:* Bernie Gofberg married his girlfriend, Molly Ozer, in 1942 before entering the service as an anti-aircraft instructor. (Courtesy of Alan Gofberg.) *Right:* The Dayen brothers, Abie and Numie, also went off to war! (Courtesy of Pearl Himmel.)

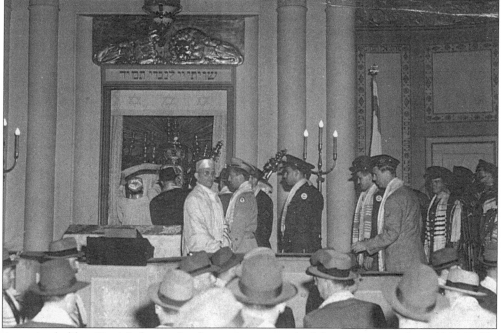

A service held at B'nai Jeshurun for the servicemen packed the sanctuary in June 1944. Rabbi Barzel held a community celebration for all who served in World War II, regardless of their synagogue affiliation. The enormous response frightened many people because it might have been the last time friends, relatives, and neighbors would see each other again. D-Day took place only a few days after that service. (Courtesy of Charlie Clamper.)

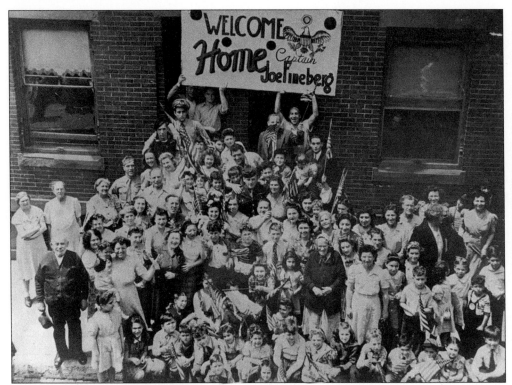

The masses celebrated the end of World War II and welcomed everyone home. Everyone from the 2500 block of Corlies Street enjoyed this occasion. Captain Joseph Feinberg, who served with the Darby Rangers, knew he was home when he stepped off the #9 trolley and was greeted by his brothers, Louie and Phil. Leave it to Sammy Miller, the neighborhood photographer, to open his wide lens to capture this 1945 photo! (Courtesy of Charlie Clamper.)

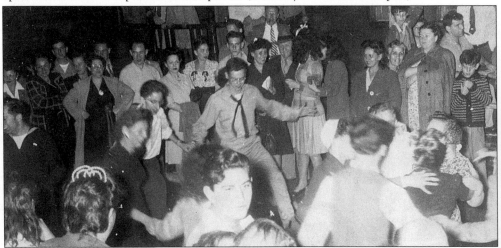

"Let there be rejoicing and merrymaking in the streets across America," was the common call from every Jewish pulpit and reader's stand. The residents from 2500 Napa Street held a block party late into the night, September 1945. Jewish people went into the street with their best clothes on and made a large *hora* (circle) to express and release their innermost fears. Life would go on in Strawberry Mansion, but it would never be the same! (Courtesy of Bernie Seiger.)

Ten
STRAWBERRY MANSION CELEBRITIES

The real secret of living in Strawberry Mansion became apparent to everyone! One could dream big and make their wishes come true with perseverance, if you coupled it with a resolution to follow through. The opportunity to succeed existed within individuals who allowed themselves to get to the right place and do whatever it took. People aimed high and worked their way to the top of their field, whether it was in medicine, education, art, science, politics, sports, or business.

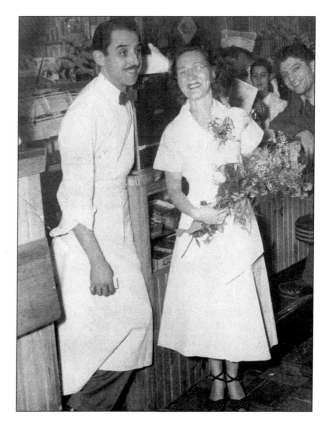

Knotty Pine Innkeepers, Lou and Kitty Calinoff, ran their famous luncheonette at Twenty-ninth and Norris Streets from 1940 to 1954. Their children, Sandy, Sherry, and Michael, helped out in the store when they were young. The Calinoffs made a difference in the neighborhood by encouraging people to shoot for the stars. Even the teachers were rewarded with free milkshakes for their commitment to education. (Courtesy of Mickey Callan.)

Left: Mickey Calinoff, son of Knotty Pine Inn owners, took singing and dance lessons at MiMi's Dance and Song Studio on 3200 Montgomery Avenue. Later, Mickey received free "Hoof" (tap dance) and acrobatic lessons in Fairmount Park from Eddie King and Joey Altee. This was the road to Hollywood for a boy from the Mansion! (Courtesy of Mickey Callan.) *Right:* Sandy Stewart, daughter of Sam and Sallie Galitz, was from the same neighborhood as Don Potter and Mickey Callan. With the help of her aunt Esther, Sandy saved her recess money to travel downtown for singing lessons from Artie Singer. Her lucky break was the Horn and Hardart Children's Hour before going to New York to star on the Perry Como show in 1960. (Courtesy of Sandy Stewart.)

Don Potter came from 3214 W. Oxford Street. As a child, Don was taught Hebrew by Grand Rabbi Moishe Lipschitz. He had his bar mitzvah at Reform congregation Keneseth Israel. "Uncle" Max Rosenfeld allowed him to attend Cooke Junior High School and played an important role in Don's ultimate move out to Hollywood. As an entertainer, Don took his cue from Al Joelson, who he imitated after viewing his films at the Park Movies. (Courtesy of Don Potter.)

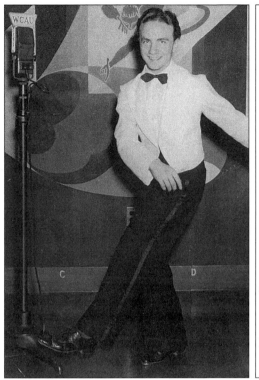

Left: Woody Goldberg and his sister, Bernyce, from the 2500 block of New Kirk Street, were dancers and comedians. Woody danced on the Horn and Hardart Children's Hour as "Junior," as well as performing on many radio programs, plus night clubs. (Courtesy of Shirley Shapiro.) *Right:* Phyllis Lewis from 3232 W. Norris Street, daughter of Al, manager of Park Movies, adopted her niece's middle name, Merrill, and performed with the "Mansionites" (formed by Jackie Lee, Mr. Hot Piano). In 1966, Merrill joined Ginny Shaw to dance, sing, and amuse thousands of people. Moe Shames booked the ladies for weekly engagements. (Courtesy of Phyllis Lewis Gross.)

Larry Fine of the Three Stooges was born in South Philadelphia and migrated with his parents and sister to Strawberry Mansion. The family resided on Clifford Street from the 1930s through the 1940s. "Why certainly" the Mansion affected Larry's ad lib moments in film! (Courtesy of Manny, Bobby, and Steven Rosen.)

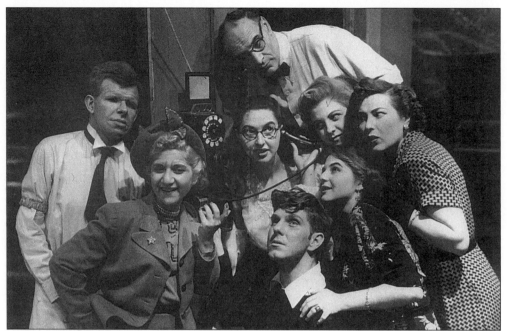

Strawberry Mansion produced many stars. Some local talent were dancers and singers, some performed on Broadway, and others went to Hollywood. Sylvia Kauder, from Thirtieth and Susquehanna Streets, acted with the Neighborhood Players, a drama group from Fifth and Bainbridge Streets in South Philadelphia. The theatrical production *Happy Birthday*, directed by Milt Jacobson, also featured Sylvia's friend, Pearl Himmel, who was also from the Mansion. (Courtesy of Pearl Himmel.)

Big stars came from the Mansion! The drama *The Biggest Thief in Town*, starring Marvin E. Richman, included Richard Lesseraux, Sam Elber, and Pearl Himmel. Marvin went on to Broadway and films, Sam became a director and teacher of drama, and Pearl made her debut on stage after answering an advertisement in a 1952 *Strawberry Mansion Gazette*. (Courtesy of Pearl Himmel.)

Sammy Miller, the famous Strawberry Mansion photographer, always had a cigar in his hand while taking photos. Another trademark of this man from Natrona Street was his dog "Pete-y," a small white and brown terrier, in the pictures. Sam took many neighborhood photos for the *Strawberry Mansion Gazette*. This 1940 photo caught Sammy, Pete-y, and Natalie Kushner at Kay's Pharmacy. (Courtesy of Paul Kushner.)

Jerry Fertman and friends celebrated his bar mitzvah at the Broadwood Hotel in the 1950s. The affair moved from the Aitz Chaim shul to the hotel with Jules Newman, Ronnie Levy, Seymour Brownstein, Meyer Shulik, Elaine Cohen, Beverly Wexler, Fredda Osattin, and Sam Etahkuwitz in attendance. (Courtesy of Jerry Fertman.)

Left: Dr. Sam Gross, born in Russia in 1895, moved to Strawberry Mansion in the early 1920s. Dr Gross set up his practice at Thirty-second and Berks Streets after becoming one of the first Jewish graduates from Jefferson Medical School. (Courtesy of Alan and Joan Gross.) *Center:* Dr. Dan Braslow practiced at 2840 W. Lehigh Avenue from 1962 until 1989. Dr. Braslow began his career by attending to his relatives! (Courtesy of Fran Braslow.) *Right:* Jacob Goldberg, D.D.S., came from Uman, Russian, and married his wife, Jennie, in 1922. Doc Goldberg set up his office at Thirty-first and Cumberland Streets. (Courtesy of Charlie Goldberg.)

Dr. Jack Weinstein, beloved husband, father, and grandfather, treated the whole neighborhood for more than 60 years from his office in the 2400 block of N. Thirty-third Street. When the neighborhood changed from Jewish residents to African-American residents, Jack did not budge! Jack Weinstein, pictured here with his grandchildren, was an institution in the neighborhood he loved until his death in the early 1990s! (Courtesy of Jean Weinstein and family.)

Dr. Bank................ 33RD & Diamond	Dr. Kessel............1800 N. 33RD
Dr. Berns 32ND & Clifford	Dr. Kesselman............32ND & Page
Dr. Bester............... 3100 Diamond	Dr. Kravitz................32ND & Page
Dr. Braslow, Dan2840 W. Lehigh	Dr. Kushner, Martin..... 29TH & Huntingdon
Dr. Brister...............32ND & Norris	Dr. Lindaver32ND & Page
Dr. Borden, Charles... 33RD Street	DDS Magil................. 32ND & Norris
Dr. Budin3100 Diamond Street	Dr. Maimon, Jules........ 2000 N. 31ST
Dr. Charny, Charlie.....1900 N. 32ND	Dr. Messey................31ST Street
Dr. Cornfeld.............30TH & Diamond	Dr. Needleman.............3100 Diamond Street
Dr. Dayen................3100 Diamond Street	Dr. Order, Harry..........2900 N. 33RD
Dr. Doodies..............32ND & Columbia	Dr. Persky, Abe............3100 Diamond Street
DDS Edelman, Seth.......3100 Diamond Street	Dr. Ravitz, Elkin 33RD & Norris
Dr. Fenichel Diamond Street	Dr. Rosset, Adolph 3100 Diamond
DDS Hendler31ST Street	Dr. Rossett, Ephraim......30TH & Diamond
Dr. Gash................Diamond Street	Dr Sherman, Jules.........30TH & Diamond Street
DDS Goldberg, Jacob.....31ST & Cumberland	Dr. Shore, Harold..........27TH & Lehigh
Dr. Goldman.............32ND & Berks	Dr Steinberg................31ST & Huntingdon
Dr. Greenbaum.......... 32ND & Fountaine	Dr. Sobel................. ...3100 Diamond Street
DDS Greenstein......... 31ST & Norris	Dr. Weinstein, Jack........ 2400 N. 33RD Street
Dr. Gross, Sam...........32ND & Berks	Dr Louis Wolfson 1955 N. 31ST

Doctor's Row on Diamond Street was well known, catered to a large population, and qualified as a "Hospital Center." The staff existed from 1921 until 1991. Today there are two Jewish doctors who still see patients and live in Strawberry Mansion. One's practice is at Thirtieth and Ridge, and the other's is at Twentieth and Lehigh. Dr. Leon Berns, who still practices, greets everyone and says in Yiddish, "Stay and be well."

Left: Dr. Louis Dodies, born in 1890 in the Ukraine, arrived in South Philadelphia in the early 1910s. Louis graduated in 1922, as the only Jew in his class, from Hahnemann Medical College. Louis married Rebecca Shur in 1922, and it was the first wedding performed by Rabbi Ephraim Yolles. (Courtesy of Bill Dodies.) *Right*: Dr. Leon Berns, born in 1906 in Strawberry Mansion, served his community well. Louis and Fenne Berns lived in 5 houses before settling at Thirty-second and Columbia Avenue. Dr. Berns still attends patients and follows his dad's advice to never "fall sick" to this very day! (Courtesy of Dr. Berns.)

Left: "Punchy" Norman Tarin, from 2415 N. Stanley Street, was a lightweight champion trained at Champ's Gym, near Pat's Steaks. The 1940s produced other champions including Gil Turner from Mr. Goodman's Gym on Twenty-ninth Street. (Courtesy of Russell Peltz.) *Right:* The one and only Benny Bass, from 2200 Natrona Street, won the Featherweight Championship in 1930 by defeating Johnny Jadick at the Arena. Charlie Goldberg, Benny's relative, recalls other famous fighters from the area including Al Winkler and Max Baer, who held titles in the U.S. Navy during World War II. (Courtesy of Russell Peltz.)

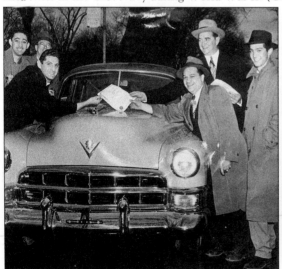 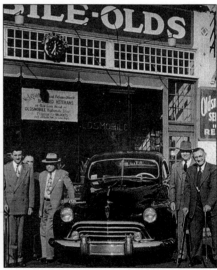

Left: Sam Israel, the son of Max and Rose who owned a fruit store, won this 1950 Cadillac in a raffle from Smith's dealership on North Broad Street. Sam won 22 other contests in his life! (Courtesy of Sam Israel.) *Right:* In the late 1930s, disabled World War I veteran Edward Dubin purchased an automobile from Reese's on North Broad Street. This unique man, with two artificial legs, had a unique car with hydraulic drive, now called automatic transmission, that people came to view from blocks around since cars were a rarity then. (Courtesy of Shirley Dubin Matkoff.)

 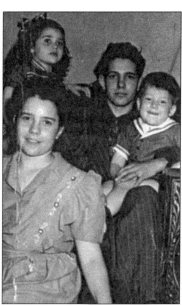

Left: In the early 1920s, Joe Daroff's family migrated from South Philly, led B'nai Jeshurun, and opened the famous Botany 500 clothing factory at Broad and Lehigh. Philadelphia became the men's clothing capital of the world! (Courtesy Allen Meyers.) *Center:* Ben Lichenstein founded Rodeo Ben's western wear during the Depression from his home at Thirty-third and Columbia. Ben and his son Gerson made wild-colored shirts for famous movie stars. Roy Rogers and Gene Audrey displayed Wrangler brand jeans too! (Courtesy Gerson Lichenstein.) *Right:* Jules Nelson founded the film processing corporation, a break away from Kodak known as Film Corp of America, in the late 1950s. Jules, his brother Eugene, and sisters Diane and Irene lived with their parents Max and Sofie on Columbia Avenue at Thirty-third Street. (Courtesy of Meyer Shulick.)

Movie theatre magnate Abe Ellis enjoyed being in the limelight with Marilyn Monroe. Abe went from a South Street hosiery jobber to investing in silent movie theatres that failed in the late 1920s when "talkies" were introduced. This man's legacy throughout the Mansion was as a leading member of Congregation B'nai Jeshurun. He left his children, grandchildren, and great grandchildren an "Ethical Will," which stated, "Life is service to his fellow human being and it is the rent we pay for the time and space we occupy here on earth." (Courtesy of Michael Ellis)

MAXWELL SAUL ROSENFELD C. H. S. "Rosy"
3116 Montgomery Avenue
Born October 26, 1906 James G. Blaine School

*"Full well they laughed with counterfeited glee,
At all his jokes, for many a joke had he."*

"Rosy" usually chews gum—when not doing that, he "chews the rag." He landed a berth as third baseman on the Varsity baseball team. We noticed that after that momentous occasion, he became quite cocky for some time. But he had reasons to be, for he was a fine player. His ever-ready grin together with his ever-moving jaws have driven many a professor to the verge of prostration. As can be inferred, "Rosy" is a veritable barrel of sunshine.

Activities: Varsity Baseball (4), Class Day Committee, Benefit Committee, Junior Football Team, Second Baseball Team (3).

Hobby: Chewing gum. Future: Y. M. H. A. Athletic Director.

Politician Max Rosenfeld grew up at Thirty-first and Montgomery Avenue and served the people in his neighborhood as a state senator. Jewish politicians proliferated in the Mansion in the 1930s; they included Ben Goldner, U.S. congressman. Local benefactors for the political careers of these men could be found in people such as Bernie Axe, clothing manufacturer; Manny Sacks, RCA Radio and CBS broadcasting pioneer; and head of CBS and owner of the Congress Cigar Company, Sam Paley. The real neighborhood politician was found in city magistrate Dogole, who settled affairs in the community. (Courtesy of Dr. Leon Berns.)

George Glick made friends with all of the neighbors and held many political offices. George was among the other Jewish people who served the community as elected officials, including state senator Harry Shapiro; Judge William Lewis; Federal Judge Charlie Weiner; state representative Earl Chudoff (whose mother was a committee woman and pushed him to run for office); and councilman Morris Apt. (Courtesy of Molly Glick and Shelly Glick Form.)

Eleven
THE NEIGHBORHOOD SYNAGOGUES

Neighborhood houses of worship anchored immigrants to Strawberry Mansion. More importantly, Jewish inhabitants of German extraction settled in the community and then transferred their religious institution to their new place of residence as they advanced in society. When the Eastern-European Jews arrived in the Mansion during the early 1920s, they created new religious centers and sanctuaries in which to pray, socialize, and educate their members. By the late 1940s, the newly arrived Holocaust survivors bolstered and helped sustain both groups of Jews to create the sacred spaces for religious worship in Strawberry Mansion.

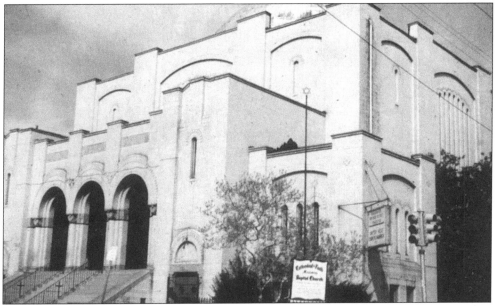

Congregation Beth Israel dates to 1840 when it formed the third Jewish congregation in Philadelphia. The third major move for Beth Israel that existed at Eighth and Jefferson Streets began only several years after it celebrated its 50th anniversary. The Purim Ball, a great social event, became the catalyst for a building fund to plan a third home at the end of the 19th century. Members of Beth Israel moved to Strawberry Mansion and wanted their synagogue do the same. In the early 1900s, architect Frank Hahn designed the new Beth Israel Temple at Thirty-second and Montgomery Avenue. The completion of this magnificent structure in 1909 opened the door to Strawberry Mansion as a recognized Jewish neighborhood.

Cantor Gedaliah Sheinfeld served the children and adults of Strawberry Mansion with a great voice, a loving smile, and a warm sense of companionship for more than 35 years—from 1922 until 1957—at Congregation Beth Israel. Born in Vachnovka, Russia, in 1892, Gedaliah immigrated with other *landsleit* to Philadelphia. Cantor Gedaliah mingled with his congregation and celebrated with Isadore and Beatrice Rosenberg on the occasion of Paul Rosenberg's confirmation in late May 1955, preceding the observance of Shavous—the Jewish holiday commemorating the giving of the Ten Commandments and the Torah to Moses and the Jews. (Courtesy of Paul Rosenberg.)

Neighborhood Synagogues in Strawberry Mansion

Aitz Chaim…3209 Cumberland (1923)
Anshe Kupler…2016 N. 32ND (1927)
Beth David…3221 Clifford (1937)
Beth Hamedrash Dorshe Sholom…3046 Berks (1923)
Beth Ha Keneseth Brezofsky…3229 Clifford (1922)
Beth Ha Keneseth Talmud Torah…30TH & York (1932)
Beth Israel…32ND & Montgomery (1905)
B'nai Jacob…1929 N. 31ST (1913)
B'nai Jeshurun…33RD & Diamond (1915)
B'nai Jeshurun Extension Cong…2029 N. 33RD (1962)
B'nai Menashe…2339 N. 31ST / Arizona (1925)
Chevra Bikur Cholim…33RD & Fountaine (1917)
Chevra Thillum & Mishnayos…3012 Cumberland (1917)
Folk Shulen…31ST & Page (1927)
Hebrew West End Jewish Community Center…2402 N. 29TH (1928)
Jewish Mute Congregation…2213 Natrona (1907)
Kerem Israel…32ND & Morse (1909)
North West Religious Association…Natrona & Columbia (1904)
Tifereth Joseph…31ST & Berks (1929)
Young Israel…1939 N. 31ST (1940)
Zicron Jacob…3012 Cumberland (1919)

Neighborhood synagogues began to sprout up in Strawberry Mansion in the early 1900s. The migration path to the area from both North and South Philadelphia marked a new era in local Jewish history. The most unclaimed and obscure institution that is little known is the Hebrew West End Jewish Community Center at Twenty-ninth and York Streets. Beth Israel built the largest edifice of its kind in Philadelphia, at Thirty-second and Montgomery Avenue, which led to the rise of a large Jewish community in 1908. The Mansion represented a microcosm of Jewish religious life across America, which was reflected in the make up of the synagogues in the community. (Courtesy of Allen Meyers.)

The Sea Scouts, an arm of Boy Scout Troop #293, represented an incredible chapter in American Jewish history. The boys graduated from cub scout to boy scout to sea scout. Skipper Marvin Epstein taught young men about boating. His unit acquired the 35-foot boat, USS *Sea Gypsy*, from the U.S. Navy and docked her at Eddington, Pennsylvania. Pictured in 1952 are Neibauer boys Mark (sea scout), Larry (boy scout), and Freddy (cub scout) with their scoutmaster. Beth Israel outfitted the USS *Sea Wolf* and docked her at Essington, Pennsylvania. The Sea Scouts represented a large boating family. (Courtesy of Marvin Epstein.)

The *chuppah* (wedding canopy), which symbolizes the home in the Jewish religion, was the most used piece of equipment at B'nai Jeshurun. Rabbis Newman, Barzel, and Pickholz were kept busy every weekend during the 37 years the synagogue served this community (1925–1962). Len Nelson and Edith Abramson, teenage sweethearts pictured under the chuppah, have been happily married since January 5, 1947! (Courtesy of Edith Abramson Nelson.)

The Miller Community Center of B'nai Jeshurun, named in honor Jennie H. Miller, catered to some of the most eloquent affairs in Philadelphia from its inception in 1922. The Sidney H. Ellis bar mitzvah dinner and dance took place here on October 16, 1926. Some of the best-known Eastern-European Jews attended this affair. They included Abe M. Ellis, Max Rudofker, Sam Furman, Nate Sporkin, Morris Yusem, Morton Weinstein, Adele Bodek Cherry, B.L. Jacobs, Joshua Bodek, and Chief Rabbi B.L. Levinthal. The Americanization of the Jewish community allowed for the combination of sanctuaries, social halls, and Hebrew schools attached to synagogue edifices. (Courtesy of Gilda and Michael Ellis.)

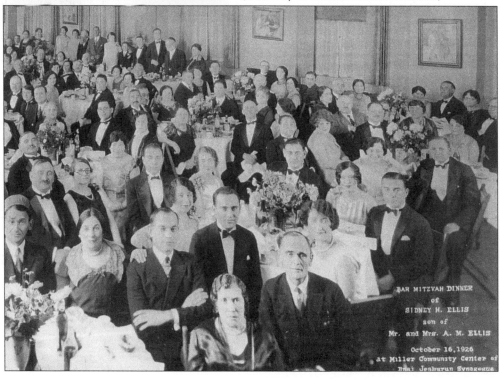

Kerem Israel Anshe Sfard was founded in 1909 as a strictly orthodox congregation at Thirty-second and Morse. The Northwest Hebrew Association hired Rabbi Baruch Spivak from Palestine. The congregation developed a schism in 1913, and a break-away group formed B'nai Jeshurun, which was less orthodox. In 1922 Rabbi Ephraim Yolles came to Strawberry Mansion from Europe and tightened the decorum even more. American society won out, and the Hebrew Sunday School Society held classes for Jewish girls by the late 1930s. The shul, which had an attendance of 600 every Saturday morning in its heyday, lingered to the bitter end and was the last synagogue to close in 1971. (Courtesy of Allen Meyers.)

The B'nai Menashe Synagogue, founded in 1925, served the growing Eastern-European Jewish population that concentrated itself in the upper end of Strawberry Mansion. Jacob Dogel, a republican magistrate, helped to arrange for a building permit to construct the synagogue, which looked similar to ones in Europe. The unique architecture had six windows and a door in the middle. The synagogue adopted its name from its benefactor Menashe Abrams, a founder of the Mt. Lebanon Cemetery in Collingsdale, Pennsylvania. The synagogue existed until the early 1960s. (Courtesy of Allen Meyers.)

Aitz Chaim Nusach Sfard opened as the second synagogue in the upper end of Strawberry Mansion in 1918. Charles Stein and Morris Neuman held services in private homes near Thirty-second and Cumberland Streets. In 1924, the congregation joined with the Zicron Jacob Talmud Torah Congregation, only two blocks away. The Talmud Torah associated with Aitz Chaim helped the Berkowitz brothers, Martin and David, on their journey to becoming rabbis. In the early 1960s, Al Freedman and Irv Wachman closed the once vibrant synagogue as the last Jewish owned stores on York Street closed their doors and moved to the Oxford Circle. (Courtesy of Allen Meyers.)

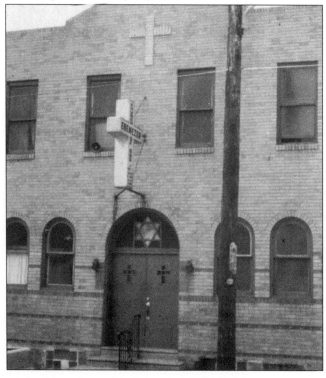

Chevra Thillum Anshe Sfard, the first synagogue to serve the community north of York Street, was founded in 1917 at Corlies and Cumberland Streets. The congregation grew, merged with Aitz Chaim, and later, another congregation took over. Parents of the students at the Zicron Jacob Talmud Torah made friends and formed another congregation. The synagogue was designed like a school with eight windows and was similar in design to the Tel Sai Yeshiva in Russia. Rabbi Yolles came to visit the Talmud Torah. Morris Merlin ran the shul and school with Shamus and Harry Mauskoff until it closed in the early 1960s. (Courtesy of Allen Meyers.)

North Philadelphia Jewish communities ran from Spring Garden Avenue, north to Hunting Park Avenue. The east-west boundaries ran from Front to Twenty-ninth Street. Jewish enclaves, such as Fifth and Erie, contained urban shopping areas where the Jewish merchants lived above their businesses and thus constituted "a Jewish community." Synagogues formed where ever more than 20 Jewish merchants were concentrated in one area. Smaller clusters of Jewish merchants formed pockets where the four corners of a neighborhood contained a grocery, tailor shop, variety store, and a drugstore. (Courtesy of Allen Meyers.)

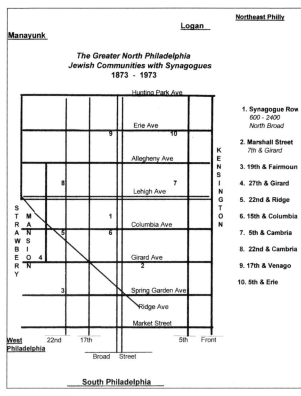

The Broad Street synagogues showcased the Jewish community in the late 19th through the early 20th century. German Jews migrated from Second and Vine in a diagonal path toward Broad Street beginning in the 1860s. One generation later, in the last decade of the 19th century, Rodeph Sholom (600 N. Broad above Spring Garden) and Keneseth Israel (1700 N. Broad and Columbia) erected large edifices that denoted their gravitation to Reform Judaism. Twenty years later, Mikveh Israel, the oldest congregation in Philadelphia, dating to 1740, migrated to 2400 N. Broad at York. Finally, Congregation Adath Jeshurun arrived at 2200 N. Broad and Diamond Streets in 1911. In their heyday, these prominent congregations created a prestigious line of edifices frequently referred to as America's Synagogue Row. (Courtesy of Dropsie College/University of Pennsylvania Judaic Studies.)

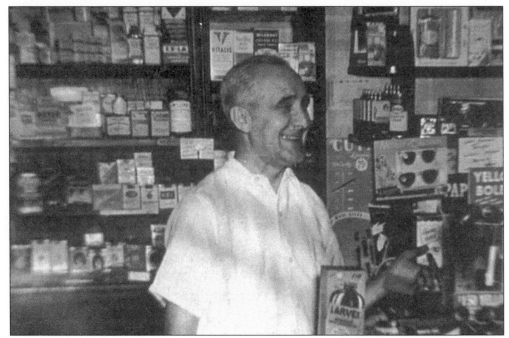

The small corner stores provided a living for many families throughout Philadelphia. Even Brewerytown, a distinctively Irish and German working-class neighborhood along Twenty-ninth and Girard Avenue, had its Jewish merchants lined up on Girard Avenue and sprinkled throughout the neighborhood. Harry Leib, a native of Romania, opened a grocery store after he married his wife, Katie, in 1928. (Courtesy of Bunny Kolinsky.)

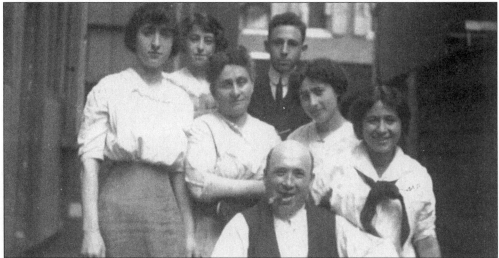

In North Philadelphia, Seventh and Girard served a large Jewish community with more than 44 synagogues within its boundaries from 1865 to 1965. The area was best known for its dairy restaurants, the Capital, the Ambassador, Gansky's, Rosenthal's, and Izzy's. The Northern Liberties Hospital, founded in the early 1920s, became the third hospital to exist in Philadelphia under Jewish auspices. It was founded by Joseph M. Goldberg, pictured here with his family, including grandfather Nathan (with the cigar), his wife Jennie, and his five children, Pauline, Sara, Benjamin, Betsy, and Mary. (Courtesy of Shirley Blumenthal Perch.)

Ten
MOVING OUT OF THE "MANSION"

Emotions ran high when families decided to move out of the area where they grew up, married, and raised their families. The post–World War II era affected this community more than any other Jewish neighborhood in Philadelphia.

Upward mobility and the GI Bill of Rights, which included availability of new housing, persuaded many couples to acquire a new house for a $1,000 deposit. The migration of Jewish people out of the Mansion was quickly filled by incoming black families, which in the later days of the Jewish community accelerated into what came to be called, "the exodus."

By coincidence, trolley lines switched to bus lines in 1956, with the exception of one key point, the Route #9 to South Philly was discontinued. Within three years (1959), 90% of the Jewish population of the Mansion left.

Moving out of the Mansion was filled with tears, aches, and pains. The Quaker Moving Company, owned and operated by the Burnstein family, provided service for many corner store and home owners. David and his sons, Ben, Sam, Jack, Ed, George, and Stanley, with the help of Minnie and Sam Steinberg and Al Feingold, ran the company beginning in 1929. (Courtesy of Richard Driban and Ed Burnstein.)

Jewish residents radiated in all directions from the Mansion. Anna and Charlie Lieberman and Phyliss, Jeff, and Mark Brodkin moved from Page Street to a new, large stone front row house at 5927 Woodcrest Avenue, in 1952. The saddest part of moving from Page Street occurred when Charlie removed the *mezziah* (a religious symbol to mark the house as Jewish according to the Bible story of the Exodus). The family selected a moving day very carefully, so it did not fall on the Sabbath or a Jewish holiday. (Courtesy of Amy Gaylon.)

Albert and Thelma Schwartz moved from N. Thirty-first Street to a modern 16-foot air-lite on Temple Road in 1950. The most difficult part for Thelma was saying goodbye to her neighbors. Al came back to the Mansion daily to deliver orders to various parts of the city for his father's kosher butcher store. The Schwartz children had plenty of space to play in their new two-tier vinyl swimming pool and large grassy lawn.

Left: In 1958, Molly and George Glick moved from the Mansion to 7434 Brockton Road in Overbrook Park. Packing dishes with sheets of crumpled up newsprint from the previous week's *Jewish Exponent* has not changed in over 40 years! The Glick's 11-year-old daughter, Shelly, posed on the front steps of her new home. (Courtesy of Shelly Glick-Form.) *Right:* Irv Silverman moved his family from the Mansion to 4895 Whitaker Avenue in Feltonville, during the 1950s. Many people did not have cars, so taxicabs were hired to transport the women, children, and dogs to the new neighborhood. Iris Silverman settled his kids, Gene and Cheryl, into the new house built by Phil Seltzer for $11,500 with a $1,000 deposit. (Courtesy of Iris and Irv Silverman.)

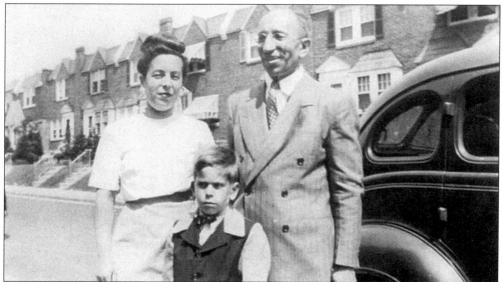

Isaac Schwartz, a traveling salesman who made his living by selling dry goods, used the trolley to get around the city. The 1943 move to 6026 Alma Street to a new Korman-built house behind the Benner Movies in Oxford Circle was a step up! After World War II, Isaac, Mina, and their son, Allen, did what only a few families even dreamed of doing—moved back to the Mansion! Mina opened a gift store at Thirty-first and York Streets and lived the best 10 years of her life! (Courtesy of Mina Schwartz.)

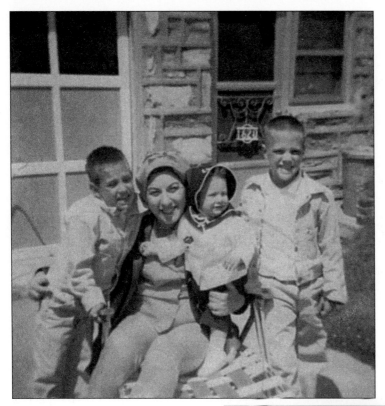

Carl Hoffman, his wife, and his children moved out of the Mansion in 1956 to a twin rancher at 1620 Placid Street, Rhawhurst-Bells Corners, above Jack's Delicatessen. The children's playground became the common driveway behind the houses where children played in a safe, traffic-free environment and made lots of new friends! (Courtesy of Carl Hoffman.)

The GI Bill provided Henry Cohen and Greg Ross's parents a lifetime opportunity—to purchase a home with no money down. The choice was simple. Henry Cohen did not want to live in an apartment or move in with his parents. Both families moved from Roosevelt Boulevard and settled in Levittown, Pennsylvania, a community laid out by the famous Levitt and Sons builders that revolutionized the meaning of suburban living after the Korean War. The one-story ranch homes came with modern appliances. Greg Ross remembers the move to a community of swimming pools, athletic fields, community hall, and synagogues on wide winding drives with names such as Sleepy Hollow and Crabtree Hollow. Henry; his wife, Rose (Jody); and their young son, Ira, stand under another Levitt feature—the car port—in 1953. (Courtesy of Henry Cohen.)

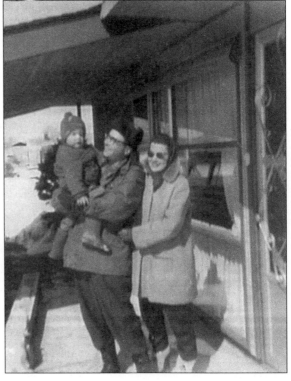

Thirteen
STRAWBERRY "MANSION KIDS" 40, 50, 60 YEARS LATER

Strawberry Mansion, separate from many other Jewish neighborhoods in Philadelphia, produced a multitude of interesting people who took their rightful place in life. "Where are they today?" is an age-old question when you reminisce. Successful reform Rabbi Henry Weiner lives in New Jersey, Abby Goldman started the mobile lunch truck business, Dr. Hank Clair is relative to the famous Clair American Legion Post, Leonard Abramson founded U.S. Healthcare, Esther Moyerman married Phillip Klein and published the Jewish Times, Bernie Waxman headed the American Jewish Historical Society in Hartford, Jay Gottlieb is a well-known lawyer, Sam Dash gave counsel to the famous Starr Report, Herb Lotman heads Keystone Foods (serves McDonald's Restaurants), C. Kety became a world renown scientist, Sidney Wallace became a well-known doctor, Herman Silverman founded Sylvan Pools, and Sam Gruber heads the Jewish World Monument Foundation in Syracuse, New York. And the list goes on!

Each person's life is a story of its own. As Rabbi Yolles said to Allen Meyers in 1985, "Strawberry Mansion was the Kibbutz of Philadelphia—I met many people, but I didn't know everyone."

Joe Smuckler went with his father, a wallpaper hanger from Russia, Friday afternoons to his grandfather's fish store on Thirty-first Street to pick out carp for the Sabbath meal. The close family ties provided Joe an excellent opportunity to verbalize his thoughts and later proved useful when he attended Harvard University and Oxford Law. In 1998, Joe and his wife, Connie, met the President of the U.S, Bill Clinton, in Washington, D.C. (Courtesy of Joe Smuckler.)

Buntzie Ellis Churchill, daughter of Russian immigrants Charles and Etta, lived at 2517 N. Twenty-eighth/Huntingdon Street above her parent's variety store. Buntzie experienced the Mansion in the usual fashion; she paraded with a paper flag and apples with candles in the center to welcome Simhas Torah at Aitz Chaim Synagogue. Paul Peck, a close friend, organized Mansion reunions with that premise in mind. As a student, Buntzie attended Girls High School and missed a social studies test and had to attend a World Affair Council meeting as a make up. Today, 40 years later, she is the president of that organization! (Courtesy of Buntzie Ellis Churchill.)

Herman Mattleman, the son of a Kosher Butcher, lived at 3018 Cumberland Street. Growing up in Mansion meant never having more than 5 minutes to eat a full meal, because the customer always came first! Herman refers to his childhood as "living in a cocoon—where one was safe and warm." The neighborhood values were shared by everyone, especially during World War II when people struggled to buy their allotment of Kosher meat. Today, Herman, a former President of the Philadelphia School Board and widely respected community leader, relaxes with his wife, Marciene, whom he married almost 50 years ago. (Courtesy of Herman Mattleman.)

Seymour Horowitz, son of Russian immigrants from Odessa, lived at Fourth and Washington Avenue (1917) before migrating to the Mansion. Albert and Alice ran Al's Hardware at 2930 Susquehanna Avenue with their daughter, Rowline, from 1937 until 1962. Seymour went from nuts and bolts and Central High School to flying aircraft in the U.S. Air Force. His son, Scott, is an astronaut. (Courtesy of Rowline Horowitz and Jack Feldman.)

David Schlessinger, son of Albert and Blanche, lived at 2688 N. Thirty-third Street as a child. His grandparents (from Poland) lived around the corner and went shopping with David in the baby coach to Gordon's Butter and Egg Store, Friedenberg Dry Goods, Pollack's Bakery, Sol's Grocery Store, and Lichman's Candy Store, all on Thirty-first Street. David founded the large East coast chain—Encore Books—and today operates a large upscale toy store chain—Zainy Brainy. David's brother, Andrew, operates Schlessinger Media/Library Video Company. (Courtesy of Ruth Gurman and Albert Schlessinger.)

Mordechai Rosenstein moved with his family from the business district of Germantown to 2529 Douglas Street in the late 1930s. Marvin, his real name, son of Louis and Dora, frequented Anna's Appetizers and Irv Wolf's candy store. As a child, Mordechai went to Atiz Chaim to learn the Hebrew alphabet for his religious training. That love of Hebrew letters shaped his life's work (calligraphy) by the way he expressed his emotions. Mordechai designs beautiful pieces of art with a Jewish feeling in conjunction with Hebrew letters that hangs in buildings, synagogues, and homes around the world. (Courtesy of Mordechai Rosenstein.)

Charlie Weiner, like many children in the Mansion, moved around with his parents to several houses. As a teenager, Charlie taught Hebrew School at B'nai Jeshurun and had Earl Chudoff as a role model. Earl's mom, a committee woman, encouraged Earl to run for public office. Earl did one better by opening the Public Swimming Pool on Ridge Avenue to the community on hot summer nights after hours. A leader can learn from others how to administer justice; the desire to do right must come from within. Today Charlie Weiner is a strong community leader and a sitting federal judge in Philadelphia. (Courtesy of Charlie Weiner.)

Herb Lewis and his family, from Thirtieth and Page Streets, had one aim in mind during the 1920s—to achieve success at anything you did! The Lewis family learned from their father what it takes to be successful—work, work, work at selling jewelry. Herb's sisters, Mildred and Helen, plus his brothers, Jack and Sheldon, were so proud when the *Clair Post* awarded him a medal for his character. Herb worked his way up in the Bulova Watch Company to Vice President. Herb suited up for the Dodgers Fantasy League in 1998, at age 83, to relive his childhood, playing baseball at Thirty-third and Diamond Streets one last time! (Courtesy of Herb Lewis and Pearl Himmel.)

Al and Pearl Nipon knew how to outfit a club house. They held the Phillies pennants during this staged press invasion of the Philadelphia Phillies locker room during their World Series run in 1980. The Nipons, from Strawberry Mansion, created media attention and focus on their designer fashions by inviting the wives of the Phillies (Mrs. Mike Schmitt, Mrs. Gary Maddox, and Mrs. Pete Rose) to stage the raid! What a marketing sensation! Ideas have been a major part of the success of the Nipon, but Pearl will tell you, "it is the loyal help and employees, that makes any company a success." (Courtesy of Pearl and Al Nipon.)

The Casino Deli on Welsh Road, east of Roosevelt Boulevard, is one of several restaurants in Northeast Philly where Mansionites congregated at all times of the day to discuss the old neighborhoods and the characters that they remember. The Gingam House on Castor at Hellerman Streets and Jack's Delicatessen in Bell's Corner on Bustleton Avenue are favorite meeting places for Jewish people who were born, grew up, and became a bar mitzvah boy, and who were confirmed at Beth Israel or B'nai Jeshurun, played baseball, worked at Cherry's, and married and raised a family. (Courtesy of Allen Meyers.)

Manny Rosen and his wife, Bobby, provide a real *hamishe* (warm and friendly) place to grab a corned-beef sandwich with all the trimmings. Of course, it costs a little more than the old days when the meal ran 65¢, complete with soda, but today, it is still a great value. The restaurant is filled with pictures of Strawberry Mansion and murals that give you a flavor of a bygone era very much alive in people's hearts! Even the popular 1990s mayor, (Philadelphia) Ed Rendell, raves about the food. (Courtesy of Manny Rosen.)

GRATZ HIGH SCHOOL
34-45 Wants You!!
Class Reunion
6/4/95 Sunday Brunch

Help us find missing classmates. Call anyone you know.
Have them call any number below.

Zelda Green Kanoff
215-233-5917

Lillie Broomer Smith
549-3987

Delores Alpert Katz
609-662-0270

Doris Kessler Sokolove
215-860-1083

More Information will follow.

The Walton School Reunion, held more than 40, 50, and 60 years after many Strawberry Mansion children grew up, moved away, raised a family, and became grandparents, reconnected many people in 1997. The fun and the excitement, and, in many cases, the sorrow of a fellow classmate passing away, is relayed to many who knew that person. This was a happy time to reminisce about people who you cared for while in school. The teachers are no longer with us, but their names often come up in conversations. (Courtesy of Buntzie Ellis Churchill.)

Your invitation to the RAMBLER'S 60th Anniversary Dinner-Dance

When:	Sunday, September 13 at 5:00 PM
Where;	Bala Golf Club*
	2200 Belmont Avenue
	Phila., PA 19131-2699
Cost:	$33.00 Per Person

RSVP By August 1, 1998 to:
Ike Silverberg 725-1725

The Ramblers meet regularly at restaurants. The guys now bring their wives; some of them were from the Mansion too! The pleasure of seeing each other is a thrill all to itself, expressed Ike Silverberg (*New Yorker*). (Courtesy of Ike Silverberg.)

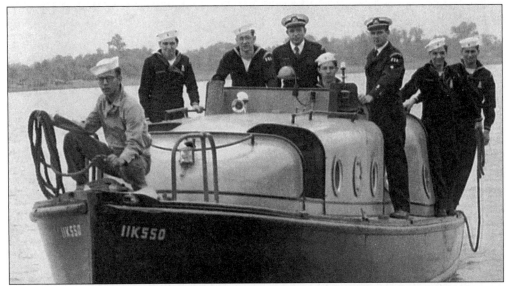

The Sea Scouts, members of the USS *Sea Gypsy*, recall stories of the high seas whenever they get together. Marvin and Mort Epstein, John Remly, Don Chagan, Alyn Rovin, Charlie Moldofsky, Bernie Dubin, Mel Aaronson, Barry Hoffman, Leonard Dubin, Harold Goldberg, Jay Rosen, Leonard Cohen, Mike Hersehowitz, and others gathered at homes to recall good times at Dale Base. Sea Scouts Troop #293 regrouped at the Neighborhood Centre on Bustleton Avenue in Northeast Philly, after the demise of Strawberry Mansion as a Jewish neighborhood. (Courtesy of Marvin Epstein.)

Scott Horowitz, the grandson of Al Horowitz, realized his dreams by becoming an Air Force pilot in the early 1980s and an astronaut. "Aim High, Air Force" is the motto we hear on television. That statement is measured in the number of orbits Commander Scott Horowitz has completed since his first launch in the 1990s. Jeff Hoffman and Scott read the Torah in space aboard the spaceship *Columbia* in March 1996, a first in Jewish history! The amazing part of this story is that pilot Horowitz and co-pilot Andrew Allen had to go into space to find out that their fathers lived four blocks away from each other in Strawberry Mansion. In October 1999, Horowitz will make another visit to space to repair the international space station. Here on Earth, we wish the crew a safe journey, Amen! (Courtesy of Rowline and Jack Feldman and Seymour and Scott Horowitz.)

Childhood friends remained loyal to one another throughout the years and kept in touch! The couples who married within three weeks of each other, see each other regularly, and when death in the group strikes, the couples lend a hand because they are family! The days when men and women listened to the Glenn Miller Band have long since passed, yet Sam and Sylvia Gonick, Gerson and Hannah Lichenstein, Marty and Ruth Lorber, Bernie and Bea Averback, and Eddie and Lil Ring remember when Lenny Meister built a jukebox and brought Artie Shaw, Benny Goodman, and Dorsey Brothers records to the clubhouse. (Courtesy of Bernie Averback and Lil Ring.)

The first computer for a business (in America) was built in Strawberry Mansion by Remington Rand at its factory near Gustin Lake in 1951. Previously, the University of Pennsylvania had worked with scientists to develop the first numerical counting computer, nicknamed "ENIAC." Remington built the new "UNIVAC # 1" for the Bureau of Census, the Army Map Division, and New York College. Jerry recalls the safety precautions taken at the plant to handle the mercury. (Courtesy of Jerry Feldscher and Jack and Rowline Feldman.)

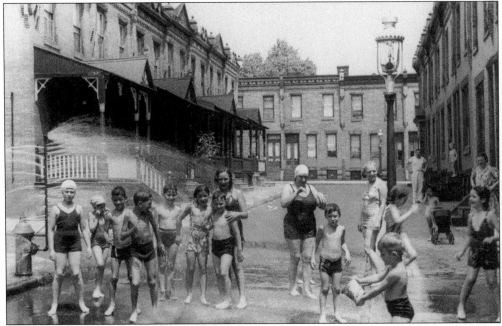

The picture of the street that Allen Meyers grew up on was a gift from Heaven! In December 1998, Bobby and Henry Shaffner shared a present that only God could have sent for from the past—my old street, the 2500 block of N. Spangler. (Courtesy of Miriam Brody.)

To Life: Remember the Mansion!

Memories common to all who lived in the Mansion, regardless of their age, include the burning of leaves along Thirty-third Street adjacent to the park, the sound of coal coming down the chute to the cellar from the coal truck, and the pungent odor of hot roof tar pitch early in the morning on a cold winter day, are locked in our memory forever.

The fragrance of Fairmount Park in the springtime and strolls in the park are deeply rooted in our souls. The daily shopping trips to Twenty-ninth, Thirty-first, or York Streets, with many smells waffling from the bakery, delicatessen, smoked fish, and butter and egg stores on Sunday mornings, still abound in our thoughts.

The sound of gushing water into the street from open fire hydrants, the whiz of half balls sailing onto rooftops, and the clanging of the route #9 trolley traveling up and down Thirty-first and Thirty-second Streets will last a lifetime in our minds.

Some scenes will never be erased from our memories, such as the pillow and bed sheets hanging out second-floor windows to air out, the window awning unfurling for the first time after a harsh winter, or the boys who came around with cans of whitewash to paint the house numbers on the gray granite curbsides.

Don't forget to invite me to your next reunion!
Please mail your memories of the Mansion to
Allen Meyers, Historian
11 Ark Ct.
Sewell, NJ 08080
tel. (609)582-0432

email: ameyers@net-gate.com